IMAGES
of America

MILWAUKEE
MOVIE THEATERS

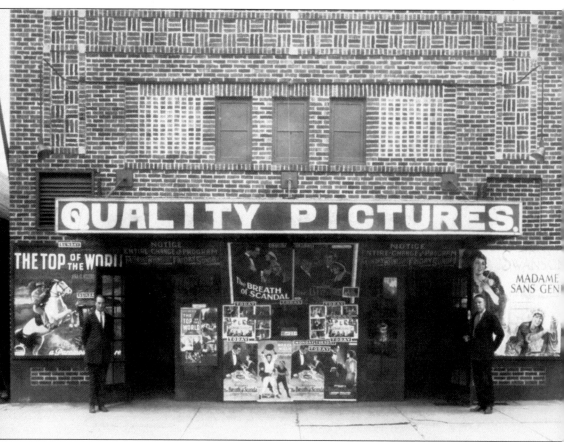

Edward Wagner (right) is seen in 1924 at his Garden Theater in South Milwaukee. Wagner started in the movie business in 1906 with a nickelodeon on Mitchell Street. (Courtesy of Leona Whitely.)

ON THE COVER: Movies playing at neighborhood theaters were often advertised with elaborate exterior signage and elaborate displays. A crowd gathered in 1932 to see "Kongo," starring Walter Huston and Lupe Velez. (Photo courtesy Milwaukee Public Library.)

IMAGES
of America

MILWAUKEE
MOVIE THEATERS

Larry Widen

ARCADIA
PUBLISHING

Published by Arcadia Publishing
Charleston, South Carolina

Printed in the United States of America

Library of Congress Control Number: 2009943192

For all general information, please contact Arcadia Publishing:
Telephone 843-853-2070
Fax 843-853-0044
E-mail sales@arcadiapublishing.com
For customer service and orders:
Toll-Free 1-888-313-2665

Visit us on the Internet at www.arcadiapublishing.com

CONTENTS

ACKNOWLEDGMENTS

Thanks to the following individuals for their contributions: astortheater.org, Sue Braun, the late Arnold Brumm, Evelyn Conway, Patricia DeFrain, Mary LaVonne Doss, Greg Filardo, Dean Fitzgerald, David Glazer, Mary Granberg, Claudia Ison, June Lassack Jens, the late Albert Kuhli, Wally Konrad, Milwaukee County Historical Society, Milwaukee Public Library, Connie Murphy, Glenn Radtke, the late James Rankin, the late Joe Reynolds, Scott Schultz, Jim Searles, Hugh Swofford, Theater Historical Society of America, Karl Thiede, University of Wisconsin-Milwaukee Golda Meir Archives, Wisconsin Historical Society, and H. Russell Zimmermann.

Recognition should also go to Joseph Brown, Chicago Architectural Photographing Company, Roman Kwasniewski, Albert Kuhli, Milwaukee Commercial Photographers, James Murdoch, Fred Stanger, and John Taylor, and all the other anonymous photographers whose vintage photographs are preserved within.

And as always, a special thanks to Judi, Emily, and Joe Widen for making life better.

Unless otherwise noted, all photographs are from the author's collection.

INTRODUCTION

In the decades between World Wars, America was madly in love with the movies. The major motion picture studios were each putting out approximately 50 films per year, and audiences swarmed into theaters once or twice each week to see as many as possible.

In 1931, with the country in an economic depression, no fewer than 12 movie theaters operated inside a six-block district in downtown Milwaukee: the Wisconsin, Palace, Strand, Merrill, Alhambra, Garden, Warner, and Riverside lined Wisconsin Avenue between Sixth Street and the river; the Miller, White House, Empress, and Princess were on Third Street between Wisconsin Avenue and Wells Street.

Attending one of the downtown movie palaces was the height of luxury in the 1920s and 1930s. The 40¢ admission was roughly equivalent to $5.22 in today's currency, but the ticket was a passport to a fantasyland where ushers, attendants, and doormen greeted patrons at the front of the house and showed them to the best remaining seats. On the way, the visitor experienced exotic architectural motifs, glittering chandeliers, luxurious draperies, and miles of plush carpeting. The entire experience was conceived as a prelude to the onscreen entertainment that featured soon-to-be superstars such as Clark Gable, Carole Lombard, William Powell, Myrna Loy, Humphrey Bogart, Bette Davis, James Cagney, and Joan Crawford.

The first appearance of motion pictures in Milwaukee dates back to the summer of 1896, when Thomas Edison's Vitascope pictures were projected before an enthusiastic audience at the elite Academy of Music. The grainy, flickering images of New York City traffic, a boxing match, and the now-famous kiss between actors John Rice and Mae Irwin thrilled patrons who paid 30¢ to sit down front or 10¢ for a seat in the balcony. Within two years, the Schlitz Brewing Company's Alhambra Theater was showing Spanish-American War footage, while other local venues featured films of sporting events, travel scenes, and natural disasters.

By 1899, movies were one of the attractions at summer amusement parks such as Chutes Park at the eastern end of North Avenue and Coney Island in Shorewood. But it wasn't until 1902 that the first actual motion picture theater came into being. Max Goldstein, a bricklayer by trade, saw the movies as a way to become his own boss. He leased a small storefront near Second Street and Wisconsin Avenue and filled it with rows of wooden benches. A piece of muslin tacked to the wall served as the screen. Admission was 5¢ for 30 minutes of silent films with music provided by a pianist.

These nickel theater owners soon upgraded into larger, more ornate auditoriums in the years before World War I. By the mid-1920s, these theaters gave way to the movie palaces that resembled Egyptian tombs, Roman courtyards, and Moorish temples. It was the debut of the Wisconsin Theater in March 1924 that ushered in the "golden age" of moviegoing in Milwaukee. With its grand marble staircases and museum-quality works of art, the Wisconsin was a palace in every way. A spectacular 75-foot illuminated sign over the street was visible for miles in the evening.

Earlier in the century, the majority of theaters were contained inside a grid, bounded by the Milwaukee River (east), Thirty-fifth Street (west), Capitol Drive (north), and Lincoln Avenue (south). But as Milwaukee's population grew, these unofficial borders continued to expand, and a number of outlying commercial districts were targeted for construction of a deluxe downtown-styled theater. By 1931, elegantly appointed theaters were thriving at the intersections of Forty-ninth Street and North Avenue (Uptown), Thirty-seventh and Center Streets (Venetian), Thirteenth Street and Oklahoma Avenue (Plaza), Farwell Avenue and North (Oriental), and Kinnickinnic Avenue and Homer Street (Avalon). Patrons of these theaters enjoyed many of the same comforts and amenities found in the downtown counterparts. Childcare services, house orchestras, and elaborate stage shows were all part of the experience. Most importantly, these neighborhood theaters maintained highly trained, attentive staffs of ushers, doormen, washroom attendants, and hat and coat checkers. Meanwhile, modest neighborhood theaters like the Lincoln, Kosciuszko, Fern, and Peerless entertained their audiences for as little as a nickel.

In 1948, the motion picture industry was affected nationwide by the enforcement of antitrust laws, which prohibited the studios, who made the films, from owning the theaters that showed them. Without the deep pockets of MGM, Paramount, Universal, or Warner Brothers to maintain the properties, the once-grand temples of amusement began to lose their luster. Carpenters, designers, coat checkers, and other employees gradually faded away. Contributing to the decline was the simultaneous introduction of television to the home market and a population exodus to the suburbs. A postwar economic boom made buying or building a home in Wauwatosa or Brookfield very affordable.

Consequently, young families were moving away from once-popular theaters like the Tower, Garfield, National, and many others. Mayfair, Capitol Court, and Point Loomis shopping centers became the new main streets complete with a theater. By 1970, nearly 80 golden age theaters had closed their doors for good. Today the Oriental, Downer, Tosa (Rosebud), and Times continue to operate as cinemas, the last of the movie theaters from another time. The Modjeska, Riverside, and Miramar also remain as performing arts centers.

Economic and social changes in the last 60 years have made the loss of these theaters inevitable. People rarely limit activities to their own neighborhood, and going to the movies is no longer America's primary form of entertainment. Accelerated lifestyles include longer work hours and increased social activities. Being able to rent, purchase, or download a film factors into a decision to go out or simply wait for it to become available for home viewing on a large television screen. Consumers spent $9.6 billion on movie tickets last year, which sounds like a lot until compared to the $35 billion spent on DVD sales and rentals. It's not good, it's not bad . . . it's just the way it is.

This book is a celebration of a time when standing on the Oriental's grand staircase made an eight-year-old girl feel like a princess, if only for a moment. Milwaukee's theaters comprised more than just starry ceilings, plush seats, and elaborate prosceniums; they are the memories of one's parents, grandparents, friends, and some of life's most precious moments. This history was compiled to preserve them forever.

One

MOVIES COME
TO MILWAUKEE

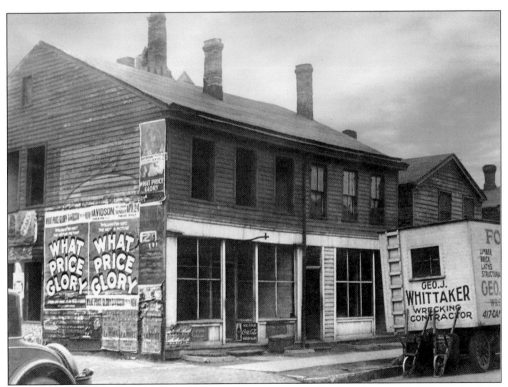

In 1842, Milwaukee was a Great Lakes trading settlement with a population of 2,000 people. Still, entrepreneur John Hustis was encouraged to open a modest theater at Third Street and Juneau Avenue. There a troupe of Chicago actors staged Milwaukee's first theatrical performance, *The Merchant of Venice*. The audience sat on wooden benches and watched a production illuminated by pails of burning tallow. Over the next few decades, residents enjoyed more sophisticated stage in increasingly elaborate theaters. Then, in 1896, Thomas Edison's motion pictures came to town. The former Hustis Theater, seen here, was torn down in the 1930s. (Milwaukee Public Library.)

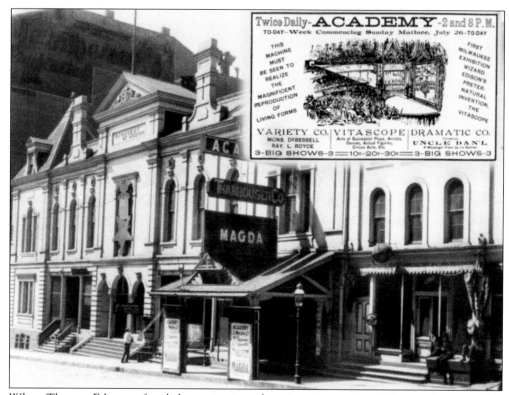

When Thomas Edison refined the projection of motion pictures in 1896, speculators quickly bought the states' rights to exhibit them. Physician M. M. Hixson and mechanic J. J. Wollam paid nearly $4,000 to secure Wisconsin and signed an exclusive agreement with the Academy of Music. Edison's Vitascope debuted on Sunday, July 26, 1896, with a top ticket price of 30¢. The show stayed for two weeks, with encore engagements in September and again in November. (Milwaukee Public Library.)

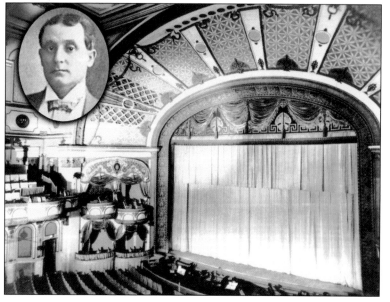

In 1898, Alhambra manager Oscar Miller showed the Biograph Company's *Views of the Spanish American War.* New films arrived every three or four weeks, which was a foreshadowing of the newsreels that played in theaters before the advent of television. (Courtesy of Milton Schultz.)

Before 1900, moving pictures could be found in theaters, museums, and parks. Important news events often played at upscale venues such as the Shubert. Boxing films were popular at the Trocadero, a saloon on Plankinton Avenue. White City (now Vliet Street's Wick Field) used films as just one of many attractions.

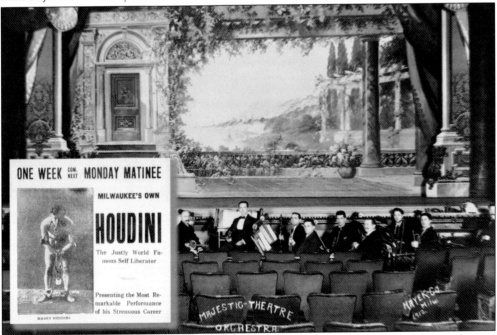

Sarah Bernhardt, Fannie Brice, John Barrymore, Jack Benny (as Benny Kubelsky and his Violin), Harry Houdini, the Marx brothers, James and Billie Cagney (as Vernon and Nye), Eddie Cantor, Will Rogers, and W. C. Fields were just a few of the performers who appeared at Milwaukee's Majestic Theater. The dance team of Fred and Adele Astaire were paid $142 for a week in October 1914. The manager's verdict was the following: "Poor singing voices, no personality, rather amateurish." Movies were shown as a way of emptying the theater in time for the next stage show. (Courtesy of Carle Lensce.)

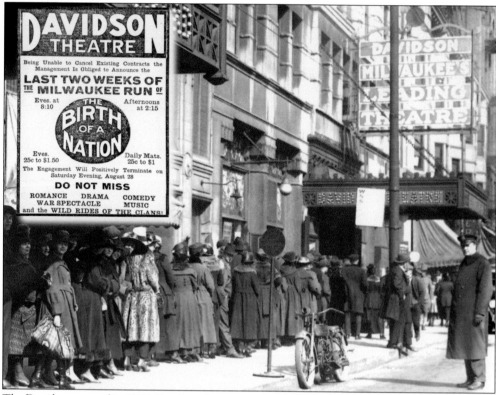

The Davidson opened in 1890. Despite a devastating fire four years later, the theater was Milwaukee's premier dramatic stage until it closed in 1954. The biggest motion picture event was a showing of the controversial *Birth of a Nation* in 1915. (Milwaukee Public Library.)

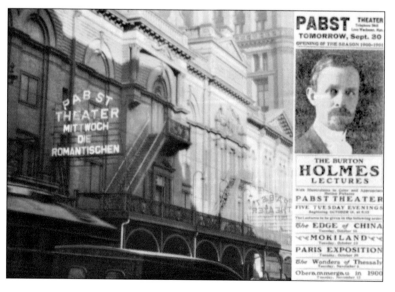

The Pabst Theater was built 1895 to replace the Stadt, a German opera house destroyed by fire. The building has hosted Lunt and Fontanne, Laurence Olivier, Sarah Bernhardt, and other legends of the stage. Lecturer Burton Holmes presented his popular travel films for four decades.

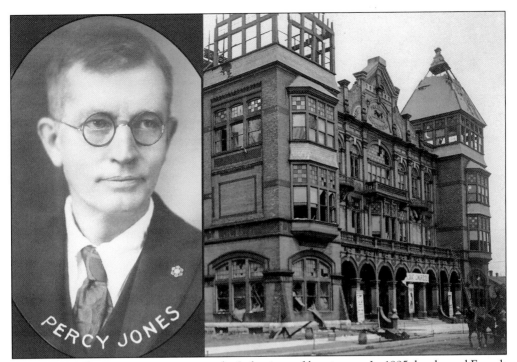

Percy Jones, a longtime projectionist at the Lake, was a film pioneer. In 1895, he showed French films in Chicago and was later hired to film the Spanish-American War. In 1900, Jones showed *A Day in the Alps* at the Exposition Building in Milwaukee. The film earned $600 over a 10-day run. (Milwaukee Public Library.)

In 1908, Percy Jones and several other theater men formed the Motion Picture and Projecting Machine Operators Protective Union. John Black (lower left) stayed in the business for 50 years until retiring in 1953. The union operated until May 1994. (Courtesy of Glenn Radtke.)

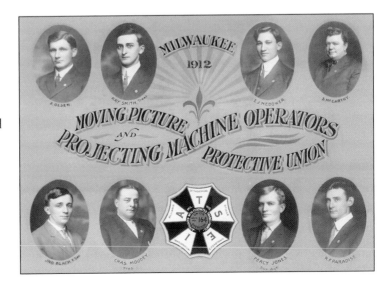

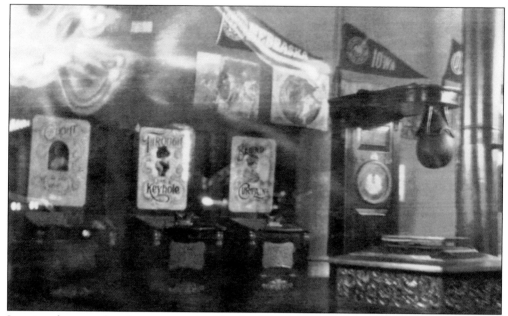

Interior photographs of penny arcades like the Wonderland at Second Street and Wisconsin Avenue are extremely rare. Risqué vignettes like *Through the Keyhole* and *Behind the Curtain* could be seen for a penny per view. Approximately 1,000 still pictures were sequentially displayed when the patron turned a crank handle, giving the impression of fluid motion that lasted about one minute. Actor Spencer Tracy, who grew up on Prospect Avenue, saw his first movies in the arcade in 1907. (Wisconsin Historical Society, #64982.)

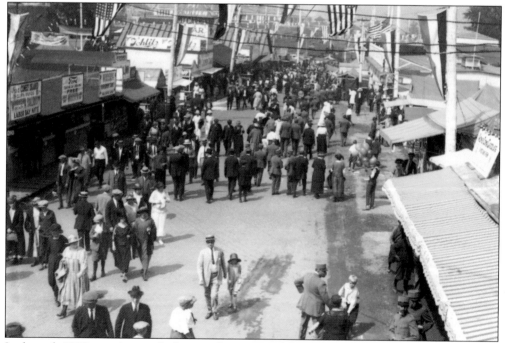

In the early 1900s, movies were little more than a spur-of-the-moment diversion at larger amusement venues like the state fair. (Milwaukee Public Library.)

14

This 1902 photograph shows the Pabst Brewing Company's summer park at Third and Burleigh Streets. Roller coasters, beer gardens, music, and motion pictures were all part of a day's outing. Pabst Park closed in 1920 when Prohibition became law. (Wisconsin Historical Society, #47550.)

In the early 1900s, Milwaukee's summer parks offered Ferris wheels, waterslides, vaudeville and circus acts, restaurants, and amusement arcades with a shooting gallery, coin-operated games, and a tent with motion pictures.

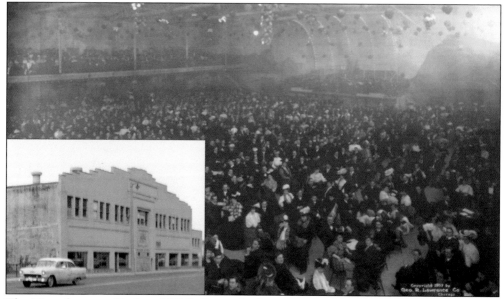

The Hippodrome at Sixth and Wells Streets had some success showing films of championship boxing matches at the turn of the century. By 1910, the building had been renovated into Dreamland, a popular dance hall run by August Wirth. In the inset, the former Hippodrome had been vacant for more than a decade when it was slated for demolition in the late 1950s. (Courtesy George R. Lawrence)

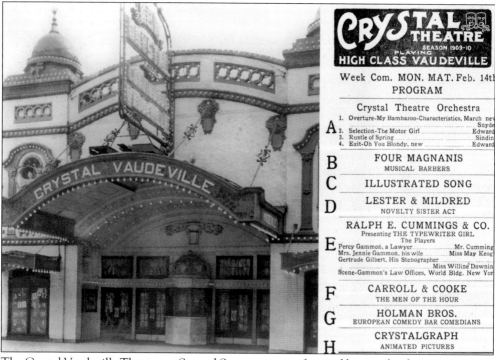

The Crystal Vaudeville Theater on Second Street was one of several houses that became a motion picture venue after being acquired by John and Thomas Saxe. Never highly profitable as a theater, the Crystal became a nightclub before closing in 1929. (Courtesy of Albert Kuhli.)

16

Two

THE FIRST
PICTURE THEATERS

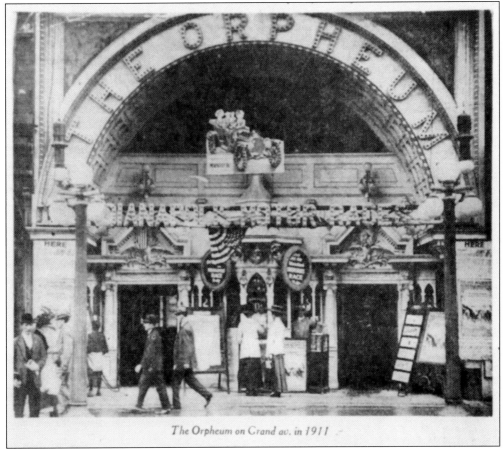

The Orpheum on Grand av. in 1911

Gaudy, brightly lit exteriors were vital to attracting patrons to movie theaters such as the Orpheum. Local billboard ordinances prohibited lurid or violent public advertising, and women were not to be shown in compromising situations. Theater owners who defied the law were fined between $1 and $5. (Courtesy of *Milwaukee Journal Sentinel*.)

The first nickelodeons were often former storefronts outfitted with camp chairs or wooden benches. A sheet nailed to the wall served as the screen. These theaters had little or no light, poor ventilation, and inadequate fire exits. Some were so primitive that the backyard or alley was used as a restroom by both sexes. (Courtesy of Mary Granberg.)

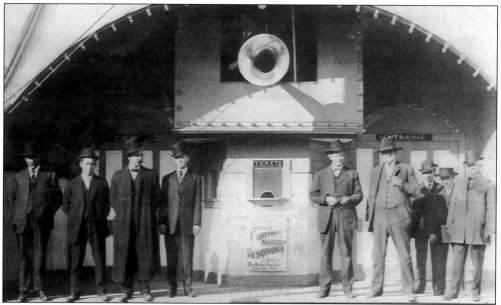

The early picture parlors, as they were referred to on building permits, accommodated from 50 to 200 people. Projectionist Edward Medower worked 12 hours a day for $15 a week. The first projectors did not have take-up reels, so the film exited into a canvas sack. When it was time to run it again, the film was pulled out of the sack and threaded into the projector. (Courtesy of Milwaukee County Historical Society.)

The Journal "Newsies" in Movies Will Surely Interest You

A MOVIE HIT

1,800 Journal Newsboys at a Picnic

See these little merchants while at play.
You'll enjoy watching them having the time of their lives.

See Them TODAY | At the **Washington Theater** THIRTY-FIFTH-ST AND LISBON-AV

In the days when there were four daily newspapers in the city, competition for readership was stiff. As early as 1912, the *Milwaukee Journal* was able to distinguish itself in the marketplace with its own motion pictures of local news and events.

In 1905, Milwaukee businessman John Freuler invested several hundred dollars in the Comique on Kinnickinnic Avenue. Nickel theaters, with their dark auditoriums, were perceived as places frequented by pickpockets and con men. Because of the stigma attached to picture theaters, Freuler concealed his interest in the Comique from family and friends. (Courtesy of Jessie Walker.)

19

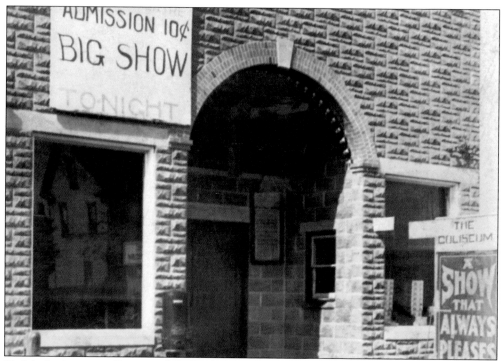

Cudahy businessmen George and Arthur Ponto opened the Coliseum in 1909 on Packard Avenue. The following year, Jacob Disch, a 36-year-old circus performer, bought the theater and renamed it the White House. When it finally closed in 1963, the theater was known as the Cudahy.

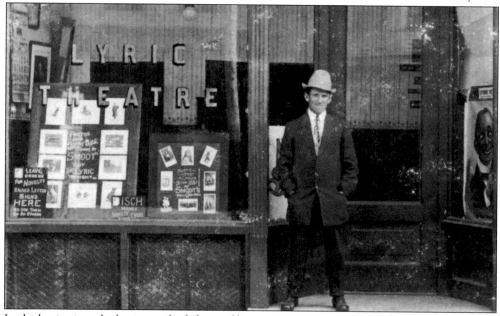

In the beginning, the business of exhibiting films was open to anyone with $1,000 in capital and the willingness to gamble it on a storefront renovation and a projector purchase. Primitive theaters like the short-lived Lyric in South Milwaukee vanished from the landscape by 1912. (Courtesy of Cudahy Public Library.)

Day laborer Edward Wagner quit his job in 1905 to open the Emporium on Mitchell Street. Soon afterward he built the Happy Hour, Park, and Wagner Theaters. Wagner sold his theaters in 1919 to build the Garden in South Milwaukee, an operation he ran until his death in 1930. (Courtesy of Leona Whitely.)

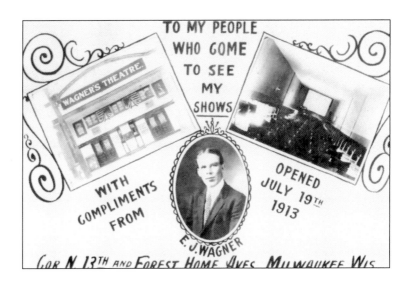

TO MY PEOPLE WHO COME TO SEE MY SHOWS

WAGNERS THEATRE.

WITH COMPLIMENTS FROM

OPENED JULY 19TH 1913

E. J. WAGNER

COR. N. 13TH AND FOREST HOME AVES. MILWAUKEE WIS.

By 1910, Milwaukee had 64 movie theaters, much to the dismay of reformers, social workers, and church groups. To placate critics, a "Closed Sunday" law was briefly enforced beginning in 1907. This included vaudeville, opera, motion pictures at the YMCA, or even a scholarly lecture. If a theater was raided, the manager, employees, and patrons were arrested.

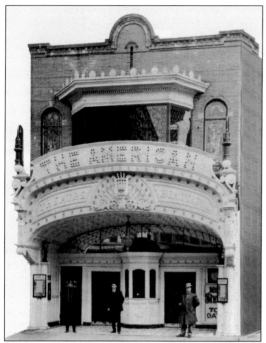

As movies gained in popularity, exhibitors were motivated to make improvements to their older theaters. The American on Third Street found a balance between an attractive facade and a comfortable auditorium with better lighting and flame-resistant curtains. (Courtesy of Milwaukee County Historical Society.)

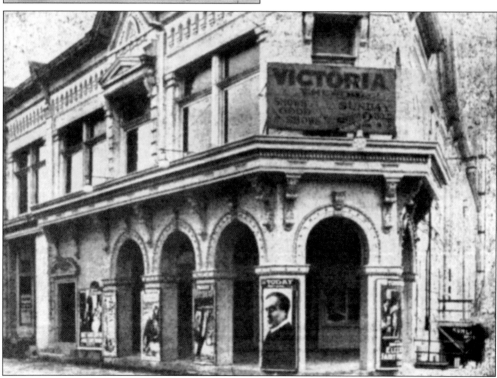

Alex Weil, owner of the Royal Lunch restaurant, filed articles of incorporation for the operation of a theater in May 1911. The Victoria was located northwest of downtown at Tenth and Winnebago Streets. The theater didn't turn a profit, and Weil sold it in January 1914. The new owner didn't fare any better, and the Victoria closed three years later.

Exhibitors relied on elaborate sidewalk advertising to draw customers' attention to the program. Ever-changing displays on heavily traveled pedestrian routes, such as Mitchell Street, ensured success for theaters like the Modjeska. (Courtesy of Milwaukee County Historical Society.)

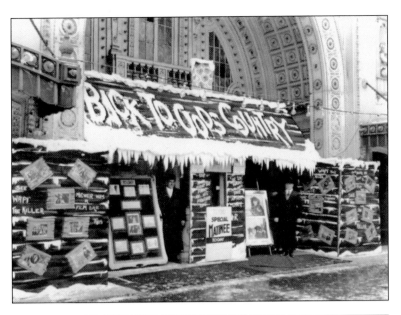

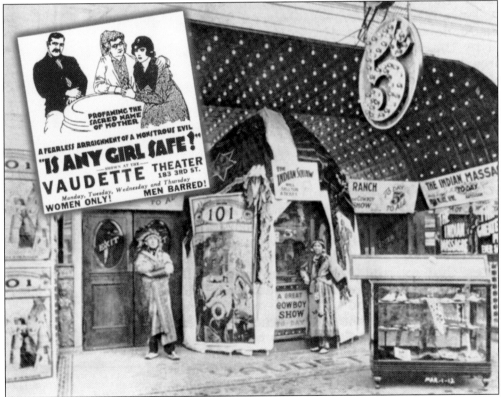

Perhaps no theater owner in Milwaukee was a better promoter than Otto Meister. In 1908, he renovated the Lawrence 3¢ restaurant into the 500-seat Vaudette. When he played a horror film called *The Glass Coffin*, Meister put a life-sized casket and wax figure in front of the theater. "We had 2,800 people a day for these films," he recalled. "They would say, 'Gracious, I hope nobody sees me coming in here,' and then pay their nickel and keep on coming."

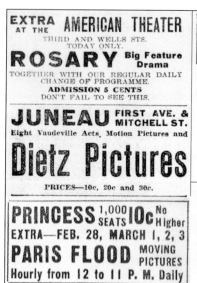

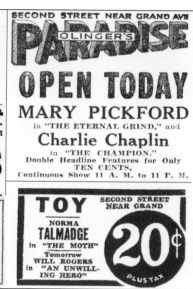

As the theaters became more elaborate, the admission increased to a dime. Many theaters changed programs two, three, and even four times each week to satisfy consumer demand.

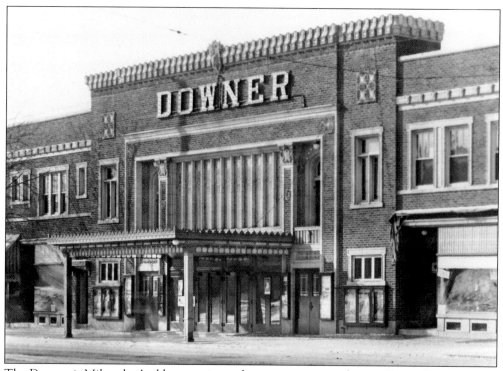

The Downer is Milwaukee's oldest continuously operating movie theater. Opened in December 1915, the 1,200-seat theater cost $65,000 to build. Offering state-of-the-art projection and sound, the Downer was recognized nationally for raising neighborhood theater standards to a new high. In 1989, Landmark Theaters renovated the Downer into a two-screen cinema.

Three

DOWNTOWN'S
GREAT WHITE WAY

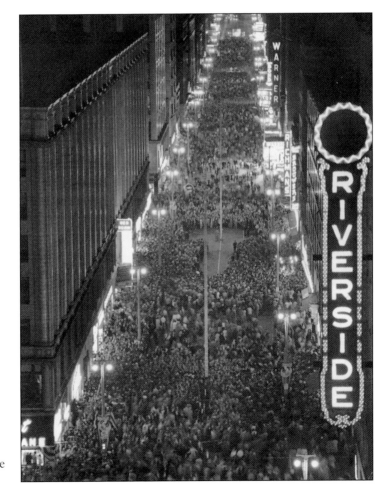

Thousands of
Milwaukeeans turned
out in the summer
of 1951 to celebrate
the reopening of
Wisconsin Avenue.
A major construction
project that stretched
from Jackson Street
to Eleventh Street
included the removal
of streetcar tracks,
installation of
underground utilities,
and major sidewalk
expansions. (Milwaukee
Public Library.)

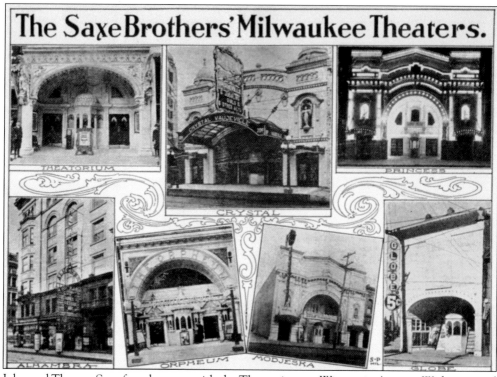

The Saxe Brothers' Milwaukee Theaters.

John and Thomas Saxe found success with the Theatorium on Wisconsin Avenue. Within several years, they had built a small chain of downtown movie theaters that included the Orpheum, Crystal, Princess, and Alhambra and the Juneau and Modjeska on Mitchell Street.

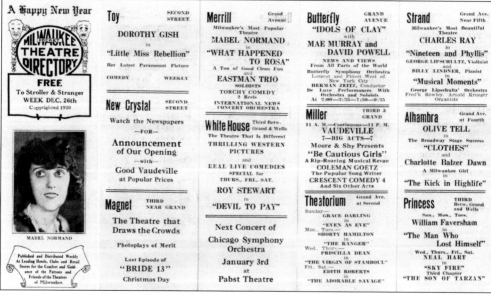

Movie advertising was typically done through small placements in the daily newspaper. Innovative companies like the Pocket Theater Directory Service provided theater owners with additional marketing options. This weekly schedule, which was distributed to pedestrians on busy streets, was slightly larger than a matchbook when folded.

By 1916, John Freuler had come a long way from his interest in the Comique Nickelodeon. He was making and distributing his own films through studios like Majestic, Reliance, American, and Mutual. In 1916, Freuler signed Charlie Chaplin to a precedent-setting deal that paid the comedian $10,000 a week plus a $250,000 signing bonus to deliver one short film each month for a year. (Courtesy of Jessie Walker.)

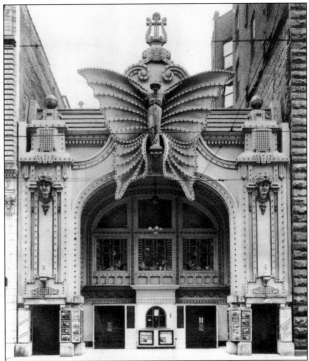

In Milwaukee, the Freuler films, most notably the Chaplins, played exclusively at the Butterfly Theater. Freuler and Otto Meister opened the Butterfly to great acclaim in September 1911. The facade featured 3,000 lightbulbs and a huge terra-cotta human butterfly. To allay public concern over tuberculosis, the Butterfly advertised a superior ventilation system that refreshed the air every three minutes. (Courtesy of Jessie Walker.)

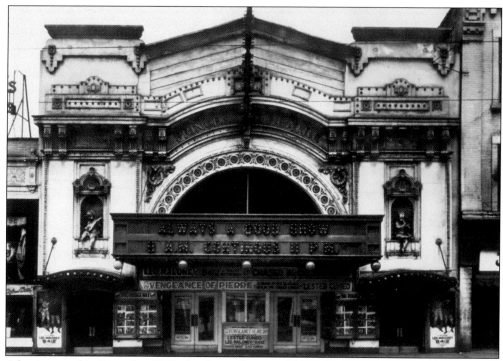

After it opened in December 1909, the elegant Princess Theater was instrumental in changing the public's perception of picture theaters. The Princess seated 900 people, and the inaugural audience was comprised of city officials, rival theater managers, and members of Milwaukee society. Mayor David S. Rose delivered the dedicatory address and owner Thomas Saxe guaranteed the Princess to be a safe, wholesome environment in which to view pictures. (Courtesy of Albert Kuhli.)

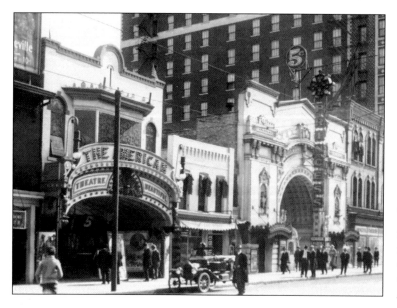

Amenities at the Princess included female ushers in smartly tailored uniforms who showed patrons to comfortably upholstered seats. The city's first theater pipe organ accompanied a group sing-along to illustrated slides, followed by music from the house orchestra. (Courtesy of *Milwaukee Journal Sentinel*.)

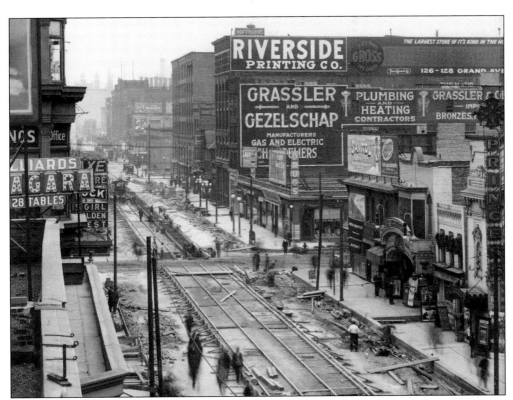

In 1913, Third Street underwent a major renovation for repairs to the streetcar track system. This project caused a temporary decline in revenues at the four theaters located between Wisconsin Avenue and Wells Street. (Milwaukee Public Library.)

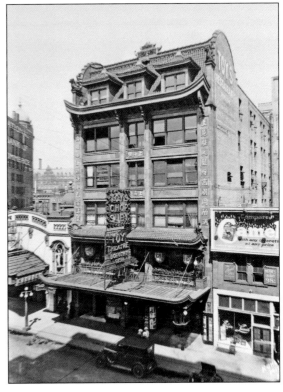

In 1915, businessman Charles Toy built the Shanghai Building on Second Street. The first floor was a motion picture theater with nearly 500 seats, above which was Toy's Chinese restaurant. The third floor held a billiard parlor and commercial office space, most of which was occupied by the various film exchanges. The Toy Theater closed in 1924, but the restaurant flourished until 1950, when it relocated to a prime spot above Walgreen's at Third Street and Wisconsin Avenue. (Courtesy of Albert Kuhli.)

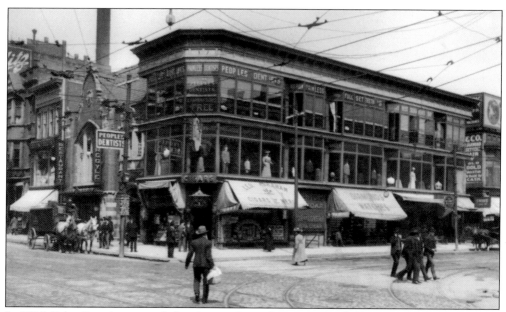

In 1906, Pabst Brewing opened the elegant Gargoyle restaurant (left) near the corner of Third Street and Wisconsin Avenue. Because the sale of beer was critical to the restaurant's bottom line, Prohibition caused the operation to fail by 1920. (Wisconsin Historical Society #47675.)

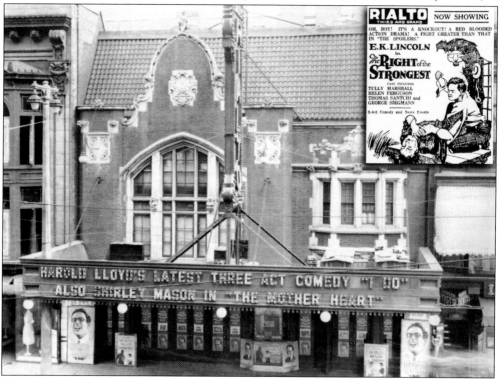

When the Gargoyle closed, the Saxe brothers renovated the property into an 800-seat theater called the Rialto. It was one of their few failures, and the theater closed in 1924. The building then became a shoe store. (Courtesy of Albert Kuhli.)

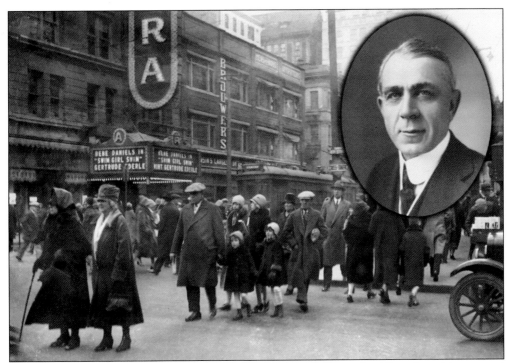

In 1905, Schlitz Brewing hired attorney Herman Fehr to manage the Alhambra. After several years of moderate success, Fehr replaced the vaudeville shows with movies. He reopened the 3,000-seat venue with amenities like supervised day care so women could attend during the day. In addition to the Alhambra, Fehr was invested in the Star and Majestic. He died in 1942. (Courtesy of Dave Prentice.)

For the opening of *The Mummy* in 1932, Milton Schultz, the Alhambra's artist, recreated eye-catching scenes from the Boris Karloff movie. The theater had a workshop located under the stage where the displays were built. When he needed extra wood, wire, or paint, Schultz went to the hardware store and bartered theater passes for the materials. (Courtesy of Milton Schultz.)

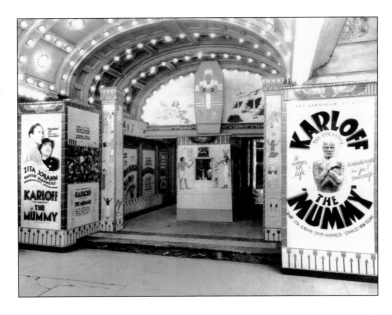

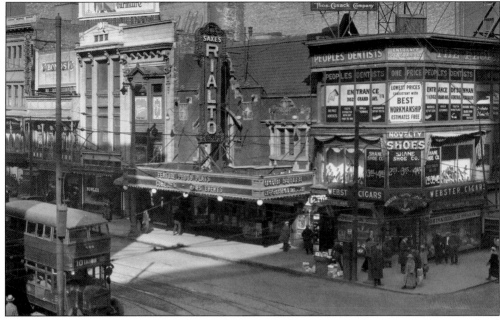

The intersection of Third Street and Grand (Wisconsin) Avenue was the city's prime piece of real estate when this photograph was taken in January 1924. In addition to a dental practice, shoe store and cigar store, the northwest corner was home to the Rialto Theater. Ten additional theaters—the Princess, American, Magnet, White House, Gayety, Garden, Merrill, Majestic, Alhambra, and Butterfly—were all located less than one block away. (Milwaukee Public Library.)

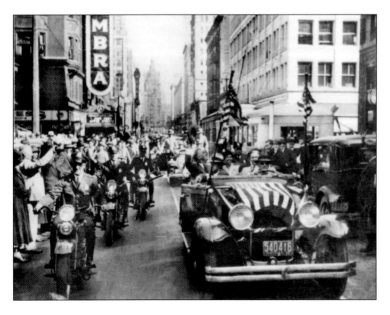

Franklin D. Roosevelt campaigned in Milwaukee on September 30, 1932. After a motorcade trip through the theater district, Roosevelt made a speech in favor of lowering taxes on the exchange of goods between the United States and friendly nations. (Wisconsin Historical Society #54380.)

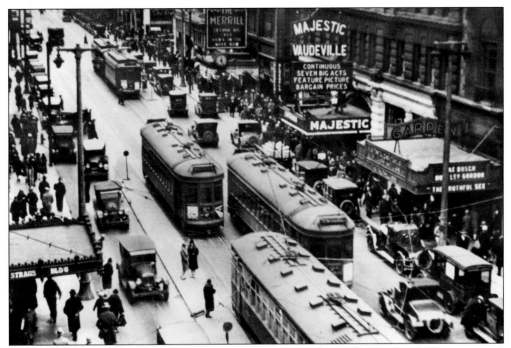

This view shows the proximity of the Garden, Majestic, and Merrill. The first "talking picture," *When a Man Loves* with John Barrymore, opened at the Garden in September 1927. Al Jolson's *The Jazz Singer* played there the following month. (Courtesy of Dave Prentice.)

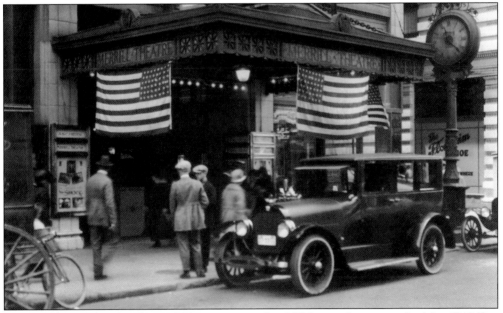

In 1915, the Ascher brothers of Chicago opened a 1,300-seat theater in the Merrill Office Building on Wisconsin Avenue. The lobby fit inside the existing structure, but to build an auditorium, the Aschers purchased an adjacent lot on Second Street. A piece of the Merrill's exterior wall is still visible, having been incorporated into the Grand Avenue Mall in 1982. (Courtesy of Wally Konrad.)

This Merrill Theater promotion in front of City Hall and the Blatz Hotel created awareness for *Fight and Win,* a movie starring boxer-turned-actor Jack Dempsey. (Courtesy of Wally Konrad.)

With only one theater, the Aschers never achieved major status in Milwaukee. Competitors like the Saxe brothers prevented them from playing the big pictures. The Merrill became more successful when the Aschers agreed to become the exclusive city theater for all of Universal's B-pictures. (Courtesy of Wally Konrad.)

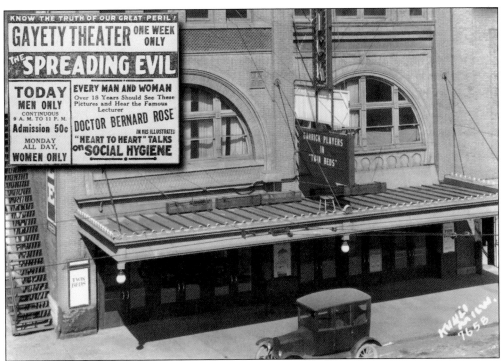

In the late 19th century, Jacob Litt's Bijou staged the popular "blood-and-thunder" melodramas of the day. When melodramas passed from public favor, the Bjiou was renamed the Gayety and then the Garrick before closing in 1928. The aging theater featured controversial films on white slavery (the practice of drugging and kidnapping young women with the intent of turning them into prostitutes) and social disease when the other downtown theaters would not play them. (Courtesy of Albert Kuhli.)

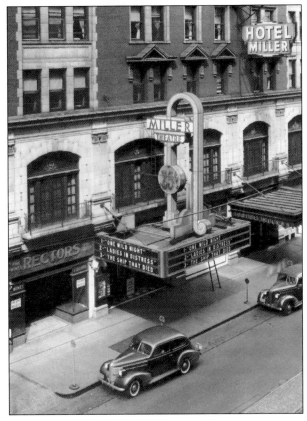

Beer baron Frederick Miller bought land on Third Street for development of a theater and hotel. From 1918 to 1928, the Saxe brothers engaged Charles Braun to book the Miller with vaudeville acts from the Pantages circuit. In 1949, the theater was renamed the Towne.

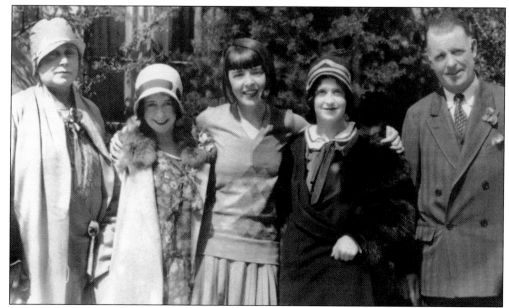

In 1927, Thomas Saxe took his family (wife Elizabeth [left] and daughters Harriet [second to left] and Katherine [second to right]) on a VIP tour of the Fox studio lot in Los Angeles. They were joined by popular actress Colleen Moore (center). Moore was the embodiment of F. Scott Fitzgerald's "flapper" girl, and her bobbed hairstyle was copied by millions of young women around the world. (Courtesy of Mary Granberg.)

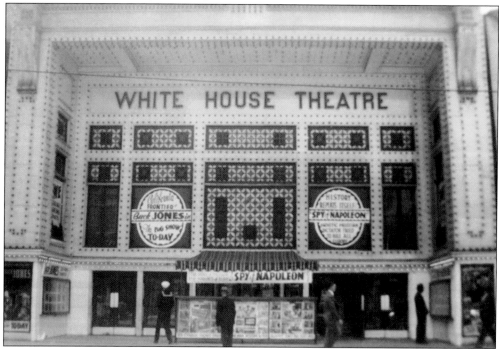

In December 1916, Otto Meister opened the White House, the only theater in town with an auditorium laid out in reverse. When patrons entered the theater, the screen was behind them as they proceeded to their seats. (Courtesy of Albert Kuhli.)

Otto Meister's Magnet Theater was erected in 1923 on the site of his original Vaudette. The adjoining White House can be seen to the right. (Courtesy of Wally Konrad.)

In 1932, the Magnet became an amusement center that recalled the penny arcades of the 19th century. After a few years, Meister closed the arcade and devoted his energy to managing the White House. The master showman was on the job every day until his death in 1944 at the age of 75. (Courtesy of Albert Kuhli.)

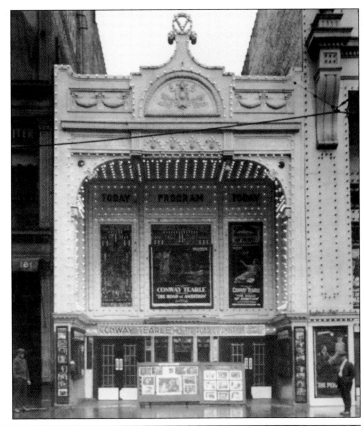

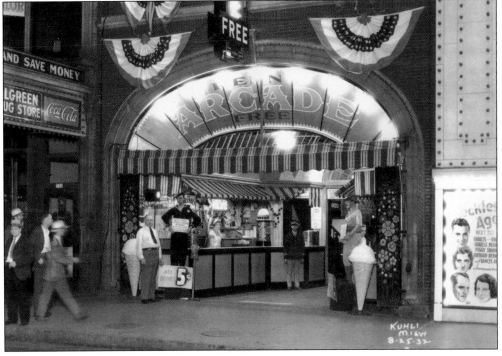

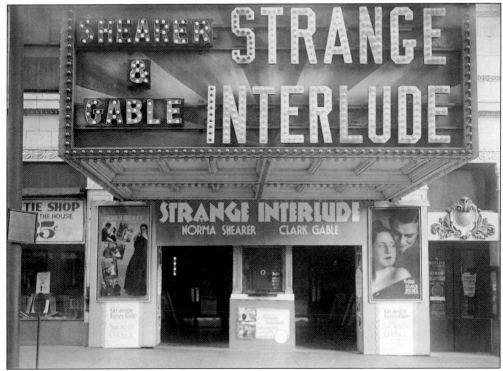

Miller Brewing built a $200,000 theater complex at Fifth Street and Wisconsin Avenue in 1915. The 2,000-seat Strand was outfitted with the latest projection equipment for "pictures without a flicker" and "perfect ease on the eyes and nervous system." (Milwaukee Public Library.)

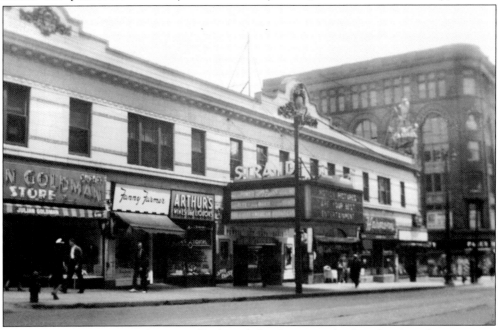

As the Strand neared completion, Miller leased the theater to the Saxe brothers for operation. The Strand prospered for the next 64 years, finally closing in 1979. (Courtesy of Karl Thiede.)

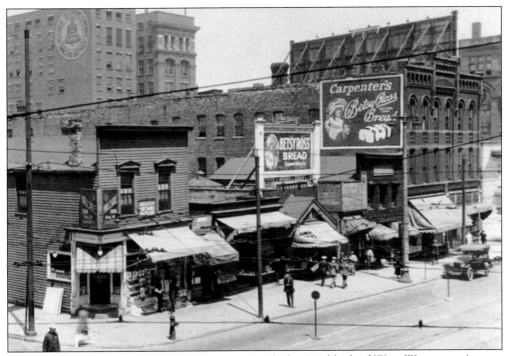

Before the Strand and Wisconsin Theaters existed, the 500 block of West Wisconsin Avenue was home to the Hillside Palm Garden (left) and the Carpenter Baking Company, home of the popular Betsy Ross bread. The Strand was built in 1915, and the Carpenter Building, which housed the Wisconsin Theater, was built in 1924. (Milwaukee Public Library.)

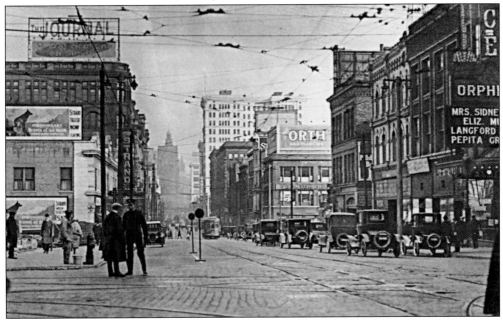

In 1922, the northeast corner of Sixth Street and Wisconsin Avenue was cleared for construction of the Wisconsin Theater directly adjacent to the Strand. Across the street, the 1916-era Palace Theater replaced the Majestic as Milwaukee's premiere vaudeville stage. (Milwaukee Public Library.)

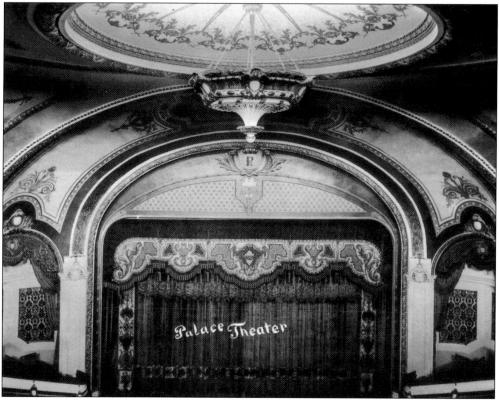

In 1916, prominent Milwaukee architects Charles Kirchoff and Thomas Rose designed the 2,500-seat Palace at Sixth Street and Wisconsin Avenue. The firm is also credited with designing the American, Colonial, Crystal, Garden, Majestic, Rialto, and Riverside. (Courtesy of Astortheater.org.)

In 1919, Milt Harman was a teenage usher at the Savoy but transitioned to the position of manager three short years later. He moved to the Garfield and hosted silent film star Francis X. Bushman in 1926. He became an executive with the Fox, Prudential, and United Artists Theater chains until his retirement in 1973. For years he handled shows at the Palace, such as Carol Channing's record-setting run of *Hello Dolly*. In 50 years of show business, Harman took only one break. From 1942 to 1950, he led the advertising efforts for the Saxe brothers' White Tower hamburger restaurants. (Courtesy of Astortheater.org.)

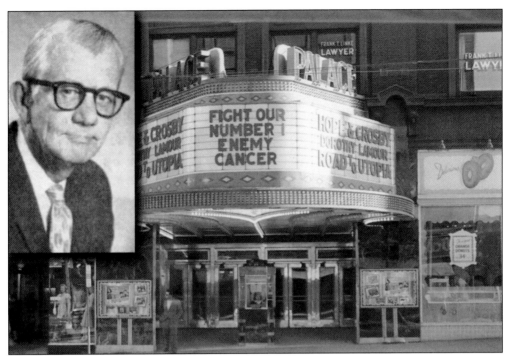

When the Palace closed in 1974, veteran manager Harry Boesel donated hundreds of the auditorium chairs to area churches. Some of the carpeting and draperies went to the Pabst while others went to various cinemas. Boesel was hired by Thomas Saxe in 1931 and worked at the Garfield, Tivoli, Mirth, Downer, Varsity, and Strand. He joined Marcus Theaters in the 1960s and retired in 1995 at the age of 84. (Courtesy of Wally Konrad.)

Until the 1960s, the largest single concentration of movie theaters was located on Wisconsin Avenue between the river and Sixth Street. The huge electric signs for the Wisconsin, Palace, Alhambra, Warner, and Riverside lined both sides of the street in 1933. (Courtesy of Dave Prentice.)

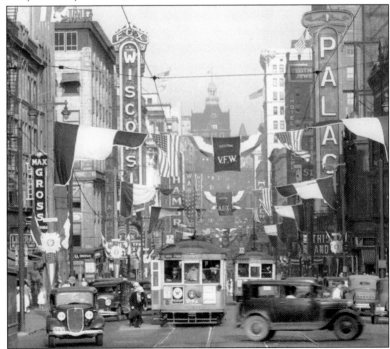

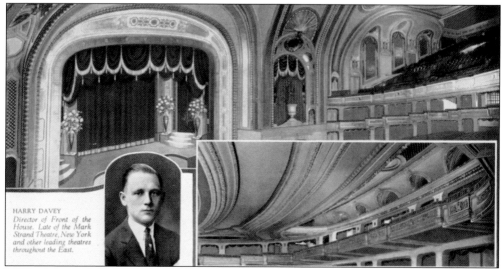

On March 28, 1924, thousands of people endured a driving snowstorm as they lined up to be the first audience at the new Wisconsin Theater. The 3,000-seat Wisconsin cost more than $1 million to build and was theater number 28 in the Saxe chain. The first manager was Harry Davey. (Courtesy of Mary Granberg.)

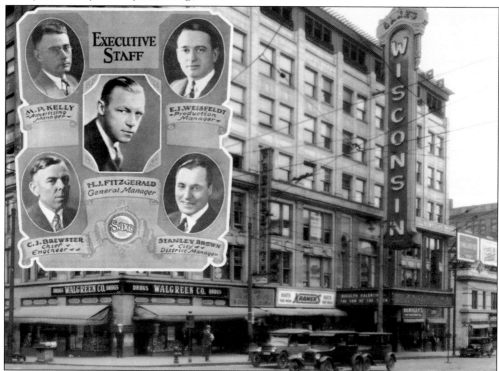

Thomas Saxe's right-hand man, Harold Fitzgerald, managed Saxe Amusement Enterprises on a day-to-day basis. Saxe hired him a decade earlier to usher at the Alhambra. Fitzgerald's staff included M. P. Kelley, who handled advertising and public relations; Eddie Weisfeldt, who was in charge of Saxe stage productions; Charles Brewster, who was the engineer behind new theater construction; and Stanley Brown, who oversaw Saxe's 12 Milwaukee theaters. (Milwaukee Public Library.)

By 1926, Saxe Theaters accounted for nearly 70 percent of the movie admission dollar in Milwaukee. As the theatrical chain swelled, the major motion picture studios began making serious offers to buy it. In December 1927, Thomas and John Saxe sold their circuit to Fox-Wisconsin Theaters, a subsidiary of 20th Century-Fox. (Milwaukee Public Library.)

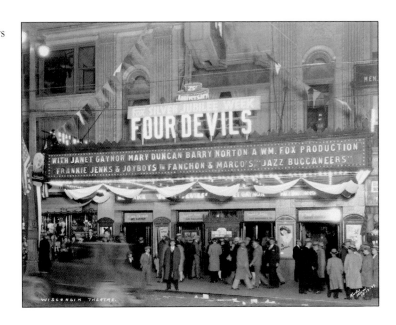

In addition to being a movie theater, the Wisconsin's stage was fully equipped to handle the largest traveling vaudeville shows as well as smaller local and regional productions. (Courtesy of Astortheater.org.)

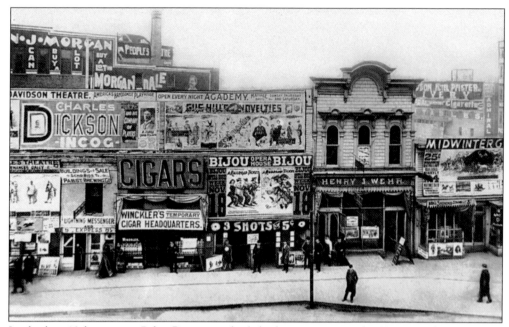

In the late 19th century, Pabst Brewing, which had an interest in the Henry Wehr restaurant and saloon, owned the block of Wisconsin Avenue overlooking the Milwaukee River. Billboards towered over Lightning Messenger, Winckler's cigar store, an amusement arcade, Wehr's eatery, and Ben's Shoe Shine. In 1926, the entire block was razed for construction of the Riverside Theater. (Milwaukee Public Library.)

The Riverside Theater, at 116 West Wisconsin Avenue, opened in 1928 as an RKO (Radio-Keith-Orpheum) vaudeville house. Decorated in the French baroque style, the Riverside sported bronze doors, marble walls and floors, gold-leaf trim, and plush wall draperies. The 2,558-seat auditorium was lit by five elegant chandeliers.

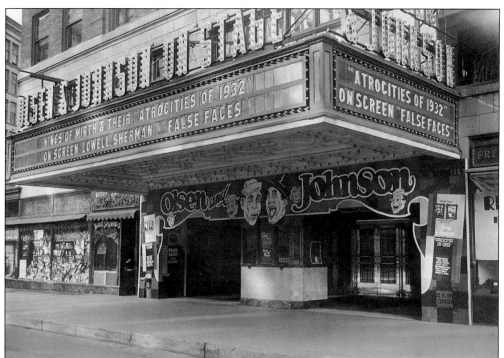

The Riverside was built by the RKO Orpheum entertainment circuit to replace the 1908-era Majestic and 1916-era Palace vaudeville houses. With the major stage shows moving to the Riverside, the Palace became a motion picture theater. The Majestic tried films as well but closed permanently in 1932. Among the many acts that played at the Riverside include Olsen and Johnson (pictured in 1932), Gene Autry, Abbott and Costello, Lucille Ball and Desi Arnaz, Burns and Allen, and Jack Benny. (Milwaukee Public Library.)

When vaudeville performers began moving to television in the 1950s, the Riverside turned exclusively to showing movies. The theater closed in 1982 when United Artists chose not to renew their lease. Joseph Zilber of Towne Realty invested $2 million to refurbish the Riverside as a concert venue in 1984.

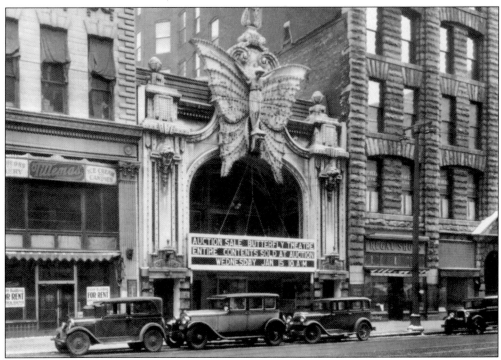

The Butterfly Theater, once one of Milwaukee's grandest theaters, was obsolete by 1930. The theater was torn down to make way for Warner Brothers' flagship theater. (Courtesy of Aaron Schultz.)

On January 15, 1930, the Olympic Bowling Alley on the west side of North Second Street sold its fixtures and equipment at auction. The building became the site for the Warner's massive auditorium. (Courtesy of American Estates.)

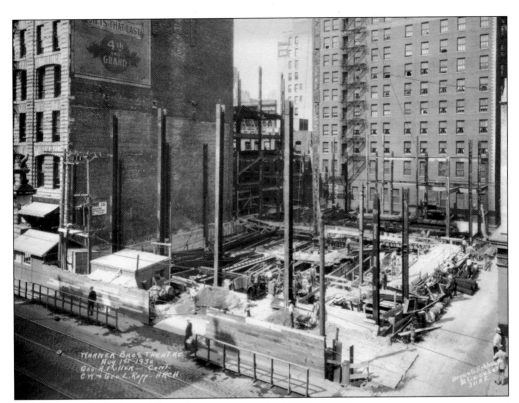

By July 1930, the L-shaped footprint for the Warner had been established. The bowling alley site was cleared, and excavation for the basement was underway. Behind it, the former Butterfly Theater building that fronted on Wisconsin Avenue had been demolished and the lot graded. (Courtesy of American Estates.)

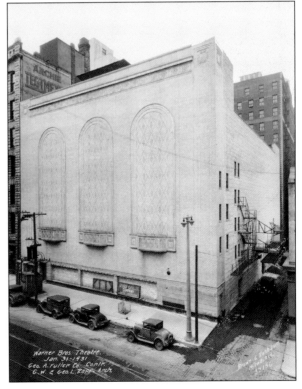

On January 31, 1931, the Warner auditorium and stage house was completed. Because so much of the building was visible from Second Street, patterned brickwork and decorative terra-cotta ensured that the theater's exterior rear wall would be aesthetically pleasing. Movie-poster display cases at sidewalk level were installed to promote current and upcoming features. (Courtesy of American Estates.)

47

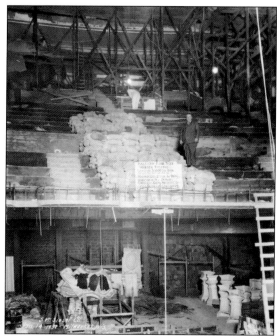

This photograph documents a rigorous weight-bearing test in which 50,000 pounds were spread over 272 square feet. After 24 hours, it was determined the Warner balcony could support 183 pounds per square foot. Pictured on January 14, 1931, is general contractor George Fuller. (Courtesy of American Estates.)

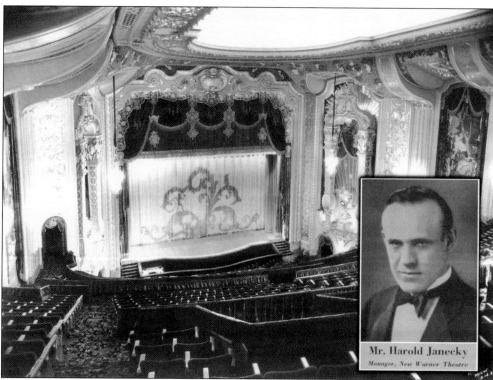

Hired by general manager Harold Janecky (inset), photographer Albert Kuhli took pictures of the Warner before the grand opening. Over a long career that began in 1917, he took pictures of many Wisconsin theaters. Since his death in 1985, Albert Kuhli's pictures have become a priceless resource to local and national historians. (Courtesy of Albert Kuhli.)

Upon opening in May 1931, the Warner became the Wisconsin flagship for Warner Brothers' chain of theaters. All the new Bette Davis, Humphrey Bogart, and James Cagney films premiered here before moving on to the second and third runs in neighborhood houses.

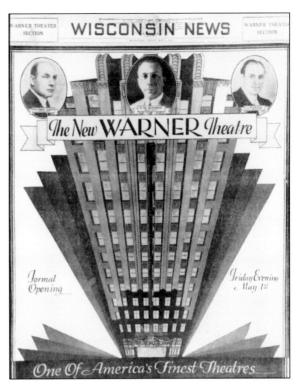

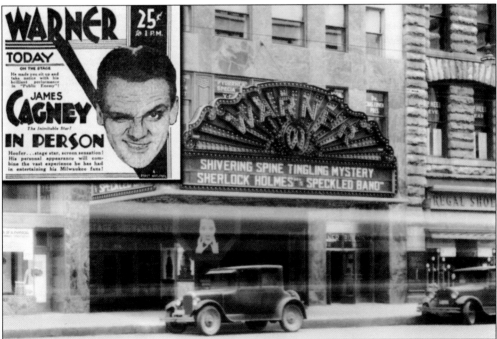

As part of their contracts, movie stars traveled the country to sell their latest film. James Cagney spent his time in Milwaukee meeting reporters, visiting the Warner film exchange, and appearing onstage before showings of the film. Cagney sang, danced, and shared stories about being an obscure performer at the Majestic a decade earlier.

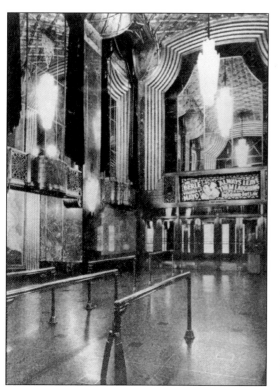

Because the Depression brought construction across the country to a halt, the Warner would be the last major movie theater built in Milwaukee until the early 1960s.

Large crowds were not unusual at the Warner, even though tickets were the most expensive in town. Admission was 25¢ until 1:00 p.m., 35¢ until 6:00 p.m., and 50¢ in the evening. Sunday evening shows were the premium tickets and priced at 60¢. Children were admitted for 10¢ during the day and 15¢ in the evening.

1939

MILWAUKEE SENTINEL, WEDNESDAY, JANUARY 18,

St. John's Cadets See West Point Picture as Theater's Guests

All of Warner's Milwaukee theater managers were on hand to assist with the opening festivities. Patrons who drove to the theater were able to leave their car at the curb. A uniformed valet parked it in the nearby Commerce Garage at Fourth and Wells Streets. Patrons who arrived on foot were greeted at the door and seated by members of the service staff.

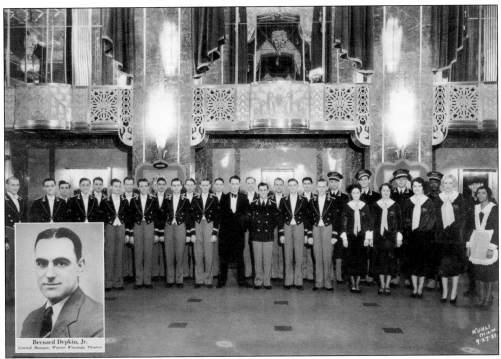

Floor manager Douglas Conine (in tuxedo) and crew chief Charles Conway (to the right of Conine) assembled the Warner staff for a final dress rehearsal just before opening. Conway gained the skills needed for crew management during his time at the Tower and Paradise Theaters. The supervisor was assistant manager Bernard Depkin Jr. (inset). (Courtesy of Evelyn Conway.)

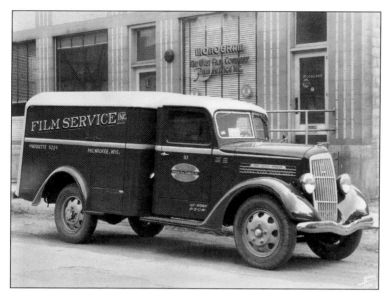

The Film Service delivery vehicles serviced Milwaukee area theaters from their Wells Street offices. This 1939 truck, built by Ransom E. Olds's motor company, was popularly known as the REO Speed Wagon. Film Service regularly kept a fleet of seven or more of these sturdy trucks on the road until the company began to cut back in the 1950s.

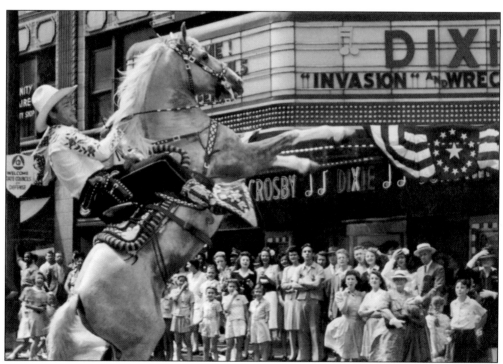

Roy Rogers and Trigger thrill a crowd in 1943 during a parade on Wisconsin Avenue. Photographer Albert Kuhli recalled that when Rogers spotted the camera, he expertly reared his horse in the air for this picture. (Courtesy of Albert Kuhli.)

Four

THE NEIGHBORHOOD THEATERS

A crowd of 500 braved a snowstorm in January 1949 to attend the opening of the Airway. The theater was built by the Goderski family, owners of the Aragon and Greendale. (Courtesy of Connie Murphy.)

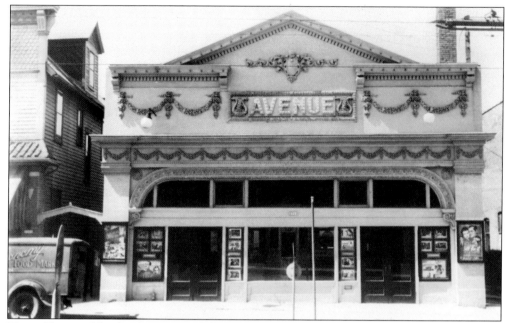

Henry Trinz and his brothers opened the Avenue in 1910. In 1919, forty-one-year-old Casimir Goderski bought the Avenue after a 20-year career as an interior decorator. Goderski performed a complete makeover on the auditorium's decor before reopening the theater as the Aragon. (Courtesy of Connie Murphy.)

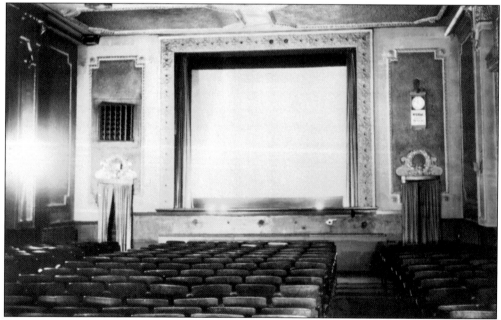

Casimir Goderski owned the Avenue, located at Lincoln and Howell Avenues, for five decades. The Goderski family left Poland in 1881 when Casimir was three. They settled into Milwaukee's south side Polish community near St. Hyacinth's, which is where Casimir attended school. He became a newsboy for the *Kuryer Polski* newspaper at age 10. In his mid-teens, Goderski served an apprenticeship in a decorator's shop until the age of 22. (Courtesy of Connie Murphy.)

New Motion Picture Theater to Be Opened Soon

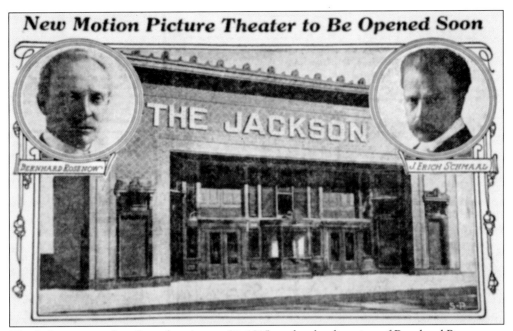

The Jackson opened on Saturday, August 21, 1915, under the direction of Bernhard Rosenow, a 20-year veteran of the Pabst Theater. Rosenow's theater was located on Jackson Street just south of Ogden Avenue. The inaugural program featured local pianist J. Erich Schmaal and the feature film *Wildflower*, starring Marguerite Clarke.

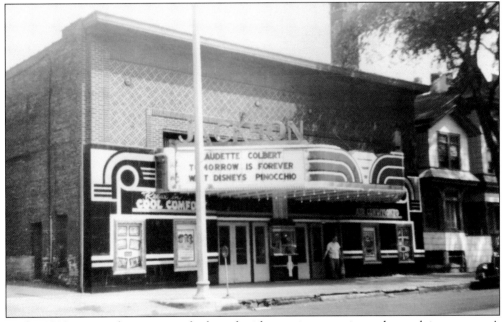

In the 1940s, aging theaters were freshened with exterior canopies and porcelain veneers. A variety of games, contests, and giveaways boosted attendance during the week. Former Jackson usher Bob Klein remembered Dish Night, usually a Tuesday or Wednesday, being the most popular promotion, especially when the dishes broke during the film. "When someone dropped a dish, the whole place would applaud," he said.

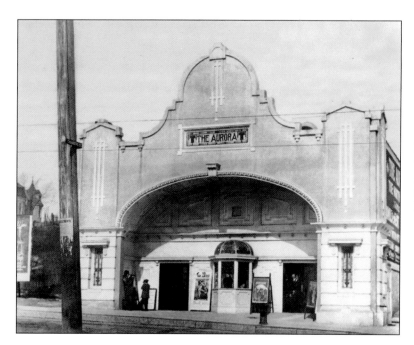

The Aurora was located at Third and Burleigh between 1911 and 1920. The 600-seat theater was owned and managed by Emil Ladwig. His younger brother Alfred was the usher. (Milwaukee Public Library.)

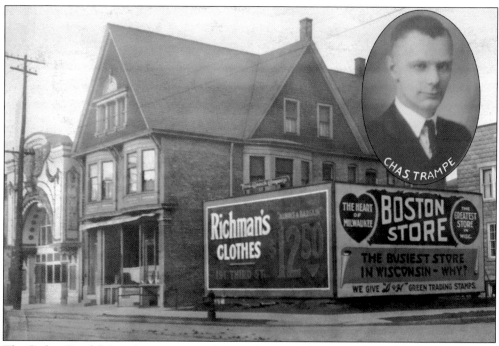

The Owl on Fond du Lac Avenue was inadvertently captured in a snapshot of the building on the corner. The theater's facade (at left) was highlighted by a large terra-cotta owl over the entrance. Veteran movie man Charles Trampe (inset) began as a projectionist here while still a teenager.

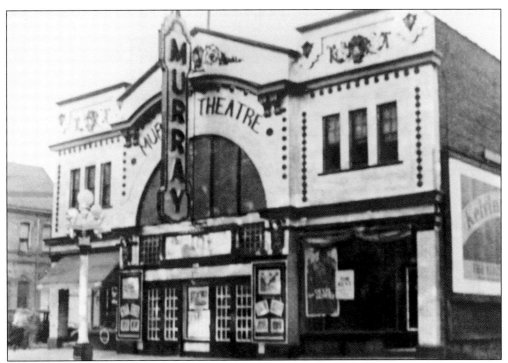

The Murray was an early neighborhood theater built in 1911 to serve the community near Farwell and North Avenues. (Courtesy of Harold Gauer.)

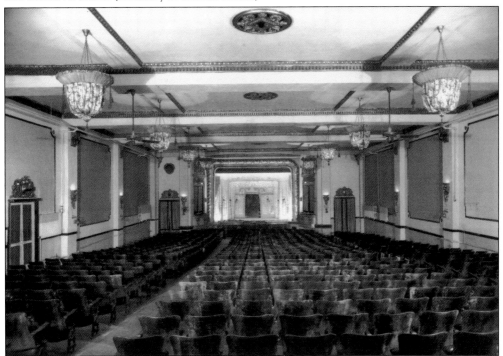

Pictured is the Murray's interior as it appeared in the late 1920s after undergoing a complete renovation. At the time, the theater was part of Jack Silliman's chain. (Courtesy of Albert Kuhli.)

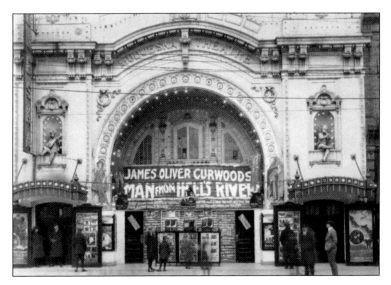

In 1910, the Saxe brothers opened the Modjeska on Mitchell Street, a shopping destination second only to Wisconsin Avenue. A near-identical twin to Saxe's Princess on Third Street, the 900-seat theater was demolished in 1923 for a more modern building that included a dance hall on the roof. (Courtesy of Albert Kuhli.)

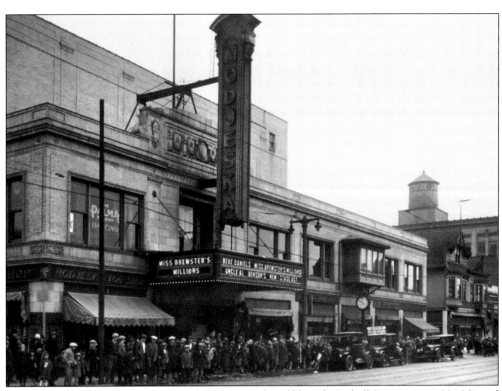

The 2,000-seat Modjeska has dominated the corner of Twelfth and Mitchell Streets since 1924. Named for Polish stage actress Helena Modjeska, who died in 1909, this theater was the second Modjeska to be built on the site. (Courtesy of University of Wisconsin-Milwaukee, Golda Meir Archives.)

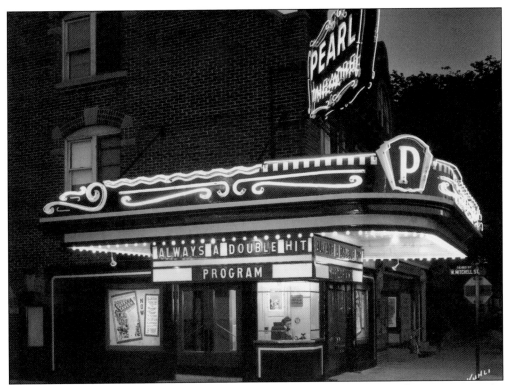

Born in Illinois in 1891, George Levine came to Milwaukee in 1918 as the district manager for Universal Pictures. At Nineteenth and Mitchell Streets, the Pearl was one of several theaters operated by Levine after leaving Universal in the 1920s. (Courtesy of Wally Konrad.)

The Granada on Mitchell Street was built on the site of an earlier theater, Henry Trinz's Empire. (Milwaukee Public Library.)

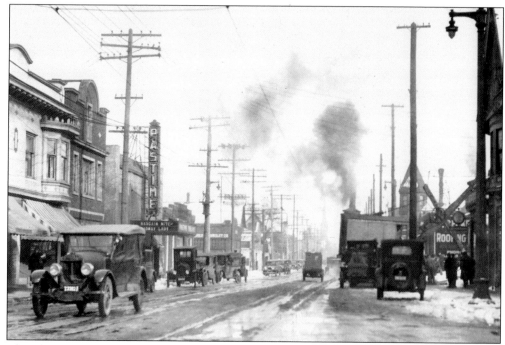

This photograph looking east on North Avenue from Twenty-seventh Street reveals the marquee for the Pastime. The owner of this 1910-era neighborhood theater did not have the capital to renovate it for talking pictures, and the Pastime closed in 1929. (Milwaukee Public Library.)

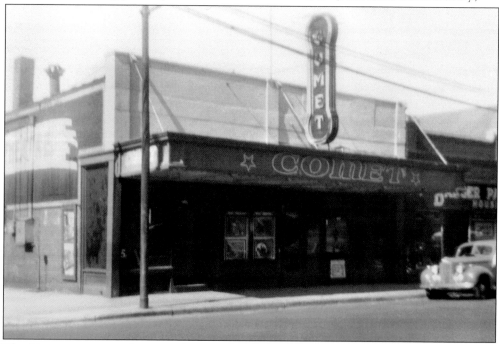

The Comet was among the many theaters once located along North Avenue. In October 1984, the building was known as the Marquee, a nightclub where Green Bay Packer wide receiver James Lofton was accused of assaulting a female employee. (Courtesy of Karl Thiede.)

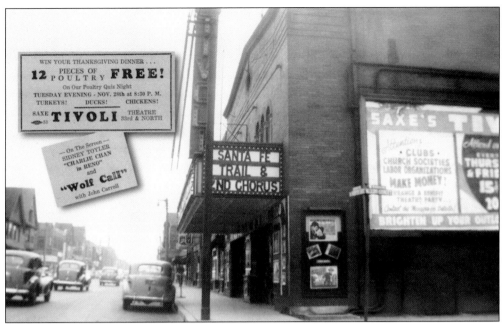

The Tivoli, located on the same North Avenue block as the Comet, operated from 1910 until 1952. John Smith managed the theater for Saxe Amusement Enterprises. (Courtesy of Karl Thiede.)

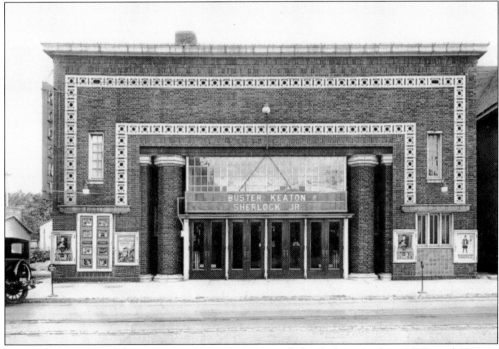

Fred Seegert operated the Regent, at Fortieth Street and North Avenue, from 1915 until 1929. In those days, an aggressive film salesman could control a small theater's screen 52 weeks a year using a practice called block booking. To get a better price, the owner was forced to buy films that were packaged in large groups with one scheduled to play each week. (Courtesy of Neal Seegert.)

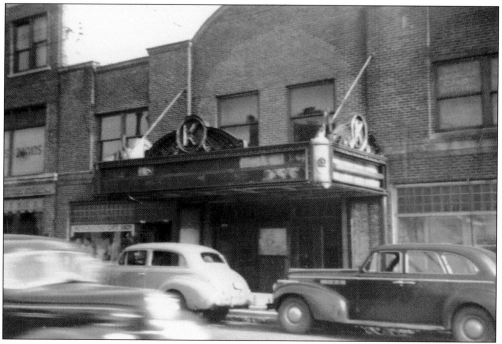

Lincoln Avenue had a large concentration of theaters within a short distance. Among them was the Kosciuszko, which operated on the corner of Thirteenth Street until 1949. (Courtesy of Scott Schultz.)

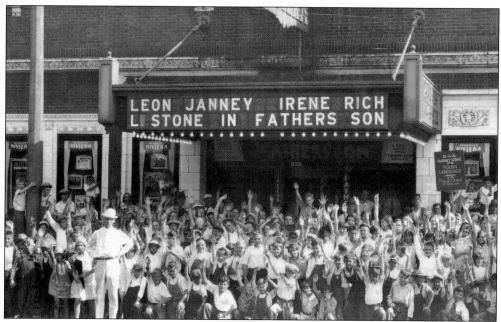

Neighborhood theaters like the Riviera at Tenth Street and Lincoln Avenue were friendly, familiar places to relax, especially in tough economic times. In June 1931, the Pulaski Council of Milwaukee treated several hundred Polish-language summer school students to a day at the movies.

The Lincoln Theater changed ownership in 1946 and continued to operate until 1955. The building is still visible today because the 1910-era lettering across the facade was never removed. (Courtesy of Karl Thiede.)

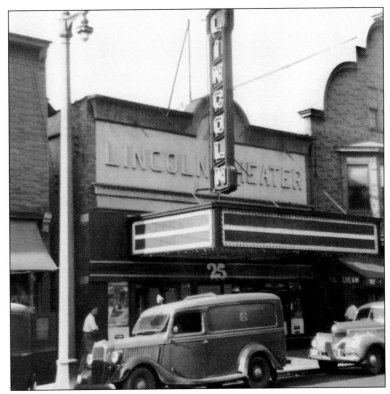

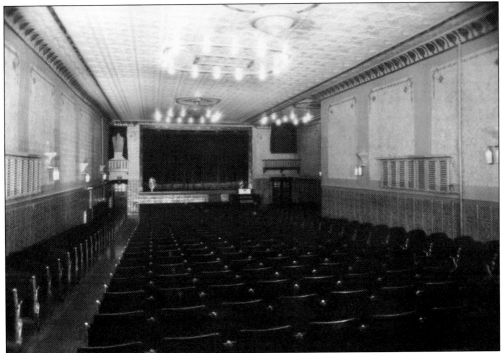

One of the more unusual auditorium layouts, the Lincoln was L-shaped with seats going around the corner to the right of the screen. (Courtesy of Jim Rankin.)

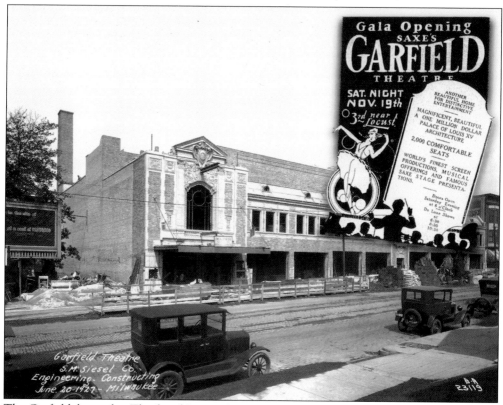

The Garfield, located at Third and Locust Streets, was one of several deluxe theaters to open in outlying business districts. Patrons could experience the glamour of downtown without leaving their neighborhood. Intersecting streetcar lines were instrumental in bringing thousands of customers to the theater in a single weekend. (Milwaukee Public Library.)

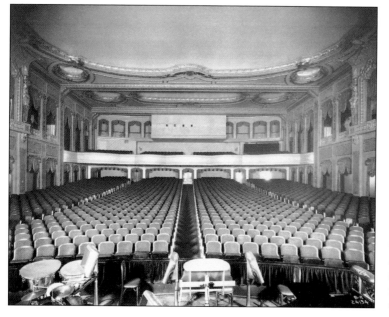

The Garfield auditorium resembled a Viennese Opera House. Although remodeled with a dropped ceiling in the 1960s, the original colors, decorative plasterwork, and other remnants of the theater's former beauty can still be seen from a spot on the second floor. (Courtesy of Jim Rankin.)

The brightly lit exterior of the Garfield was a beacon on Third Street until the mid-1960s. The theater closed due to a change in neighborhood demographics and the simultaneous opening of suburban shopping mall theaters. (Milwaukee Public Library.)

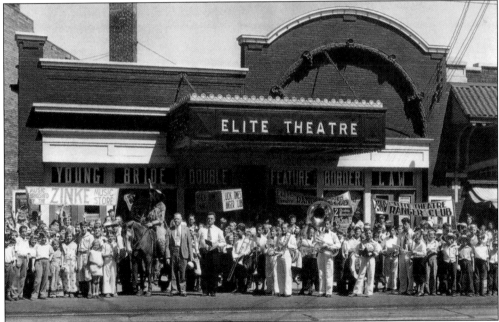

In 1932, electrician Bernard Lassack (to the right of the horse) bought the Elite on Green Bay Avenue. A hands-on owner, Lassack managed the theater and acted as the projectionist. His wife, Cecelia, cashiered, while daughters Charlotte and June ushered and swept the floors. Also known as the Mars, the theater closed as the Roxy in 1952. (Courtesy of June Lassack Jens.)

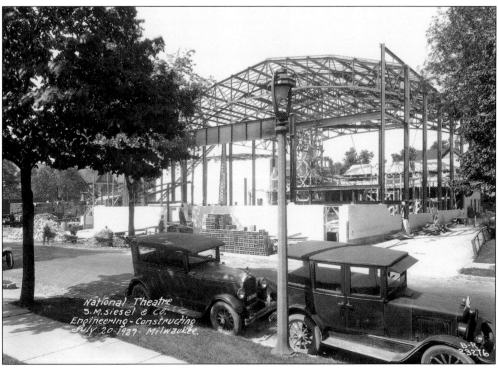

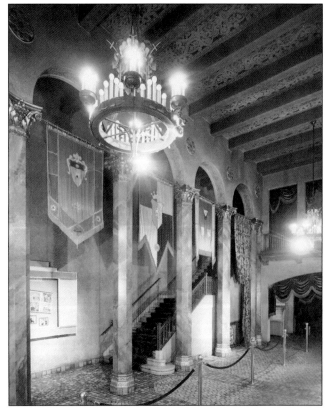

A syndicate of local investors headed by George Fischer operated the Milwaukee, Capitol, Parkway, and Ritz. In July 1927, construction was well underway on their newest theater, the 1,388-seat National. (Milwaukee Public Library.)

With a final cost of just over $1 million, the National opened in January 1928. One of the most popular features was a room off the lobby where mothers could take crying babies. A large picture window allowed viewing of the film while in the soundproofed room. (Courtesy of Jim Rankin.)

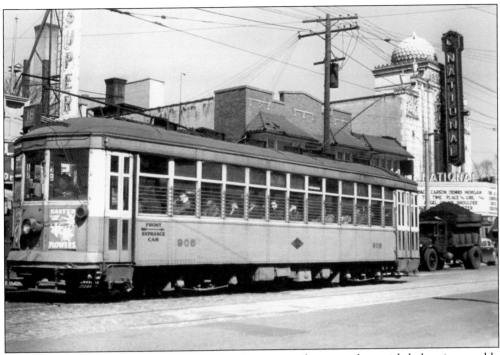

The National was designed after an ancient Roman garden, complete with balconies, marble pillars, plush draperies, fountains, and statues. Management in the 1950s and 1960s allowed the beauty of the National to deteriorate, and the theater was demolished in 1971 for a multiunit housing complex. (Courtesy of Dave Prentice.)

Originally opened in Bay View in 1926, the Lake, under the management of Thomas Reilly, was one of a dozen theaters in the Warner Brothers' Milwaukee chain. The theater closed in 1956 and became a youth club and then an audio-visual facility. Photographer Mark Gubin bought the building in 1972 and transformed it into his studio and living space.

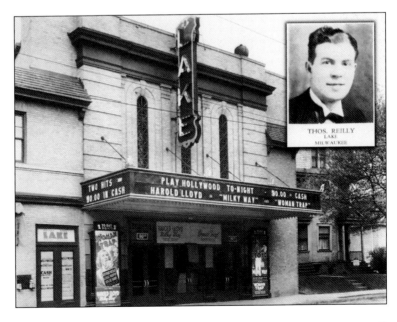

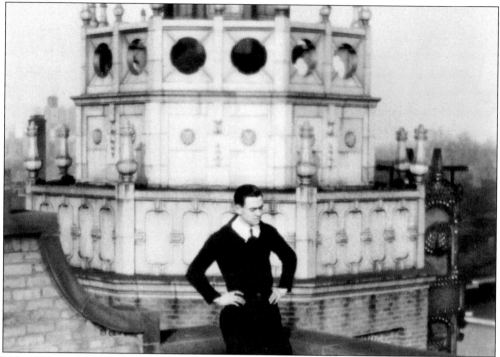

Usher George Hartwell was 18 years old when his pal Harold Shaffer took this shot atop the Tower Theater. (Courtesy of Harold Shaffer.)

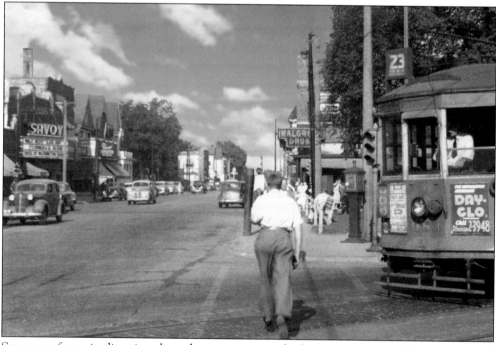

Streetcars from six directions brought passengers to the busy intersection of Twenty-seventh Street, Center Street, and Fond du Lac Avenue. Anyone wanting to see a movie could just cross the street to the Savoy Theater. (Milwaukee Public Library.)

When the Parkway opened in 1913, it encouraged other merchants to become part of Lisbon Avenue's business community. Playing at the Parkway on the day this photograph was taken was the 1926 film *Syncopating Sue*, starring Corrinne Griffith. (Milwaukee Public Library.)

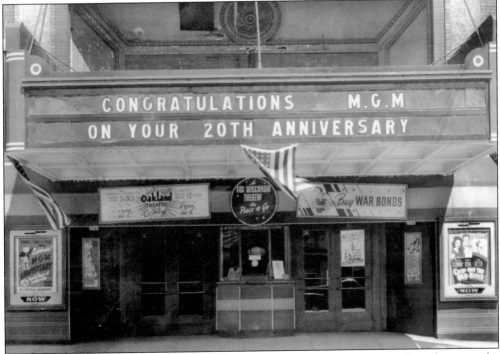

The Oakland Theater's exterior offered a variety of patriotic themes in 1944. Over the years, the building has been known as the Fred Miller Theater and the J. Pellman Theater. Currently it is a live music venue and nightclub called the Miramar. (Milwaukee County Historical Society #47748.)

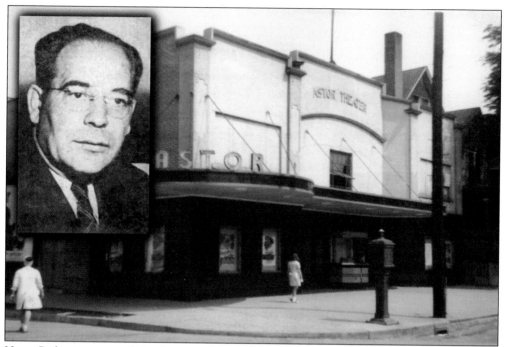

Harry Perlewitz managed the Savoy and several other houses for Saxe Amusement Enterprises until 1932, when he bought the Astor Theater on Brady Street. Perlewitz also acquired the Jackson, Miramar, and Liberty as part of the deal.

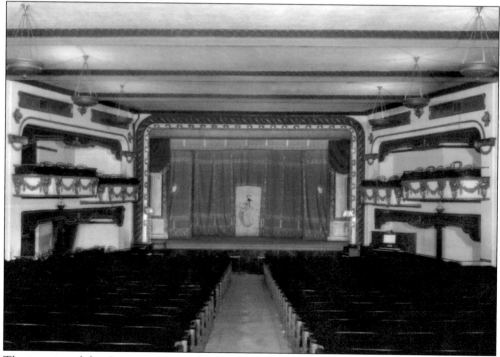

The interior of the Astor was more elegant than many neighborhood theaters of its size. The boxes near the screen were private, and each one had only a few seats.

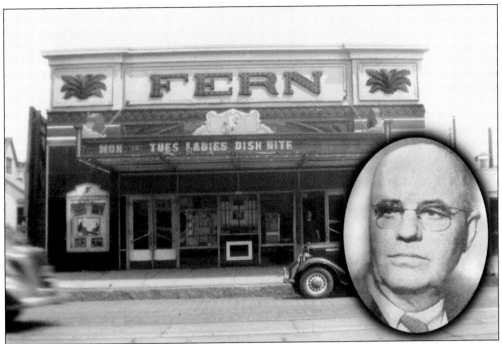

Ernest Langemack (inset) managed the Fern on North Avenue with his cousin William Maertz. Independent theater owners, having little or no money for advertising and upkeep on the property, often struggled to make ends meet. (Courtesy of Karl Thiede.)

Maertz and Langemack also operated the Colonial on Vliet Street. The theater was notable in the 1930s and 1940s because actor Pat O'Brien's parents, who lived in Milwaukee, liked to see their son's pictures there. (Courtesy of Jim Rankin.)

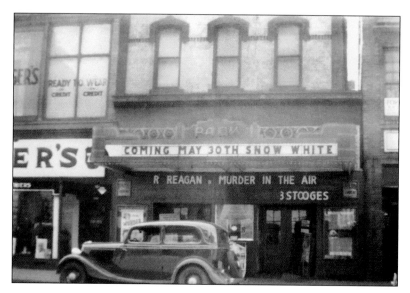

The 400-seat Park at Seventh and Mitchell Streets was one of a dozen theaters that once lined both sides of this popular six-block shopping district. (Courtesy of Karl Thiede.)

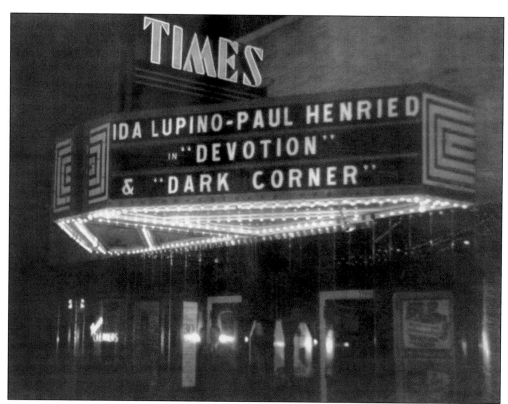

While growing up in Wauwatosa, *Time* magazine film critic Richard Schickel often went to the nearby Times Theater. In *Good Morning, Mr. Zip Zip Zip*, he wrote, "The point was to surrender to a movie's thrall, be unable to shake it off on the walk home. You could imagine that the shadows might hide a Japanese sniper. Or, conversely, that you could sing and dance like Gene Kelly—though never like the more elegant Fred Astaire." (Courtesy of Paul Finger.)

In the 1940s, Casmir Goderski streamlined the Aragon's exterior with a new sign and a porcelain facade at street level.

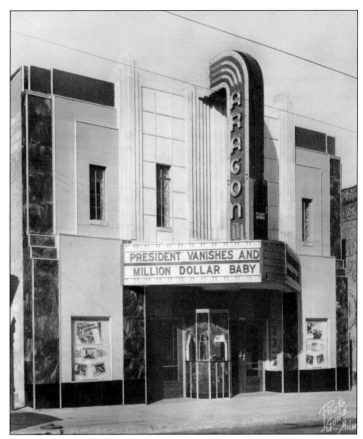

In the late 1950s, the Aragon's new owner renamed it the Pix. It was a short-lived venture and closed permanently in 1961.

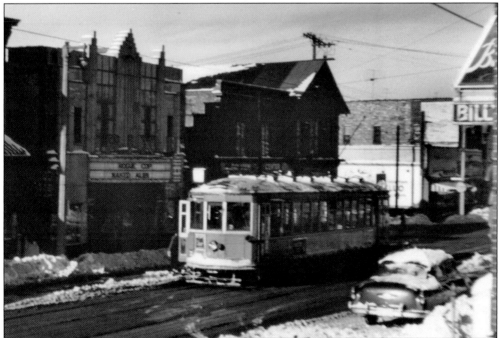

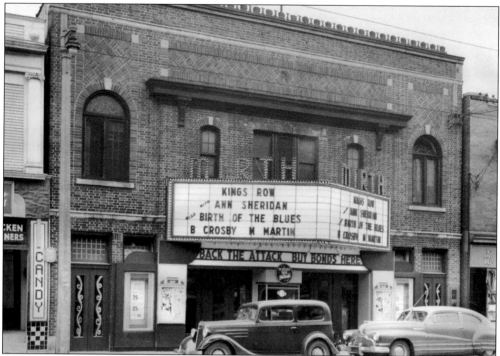

The Mirth operated on Kinnickinnic Avenue from 1913 until 1952. George Harrmon and Richard Honek were the managers when Saxe Amusement Enterprises owned the theater.

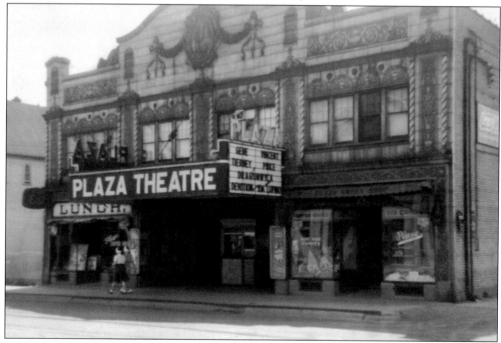

Located at Thirteenth Street and Oklahoma Avenue, the Plaza was one of 16 theaters to open in 1927. The construction in that one year added 18,200 seats to Milwaukee at a cost of $7 million, a number that has never been surpassed.

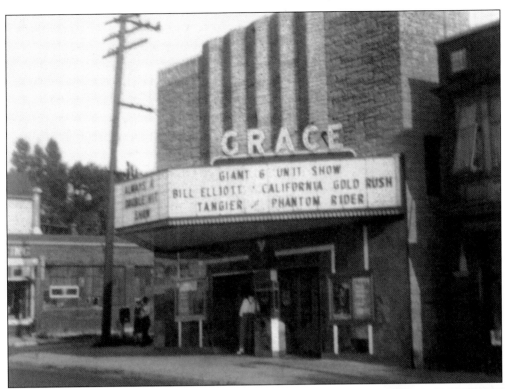

Originally built in 1911, the Grace at Thirty-third Street and National Avenue was one of three theaters operated by former Universal Pictures executive George Levine. The Grace closed in 1957. (Courtesy of Scott Schultz.)

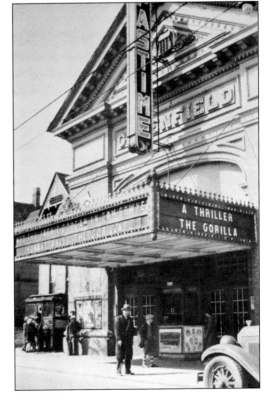

The Pastime at Twenty-second Street and Greenfield Avenue was originally called the Greenfield, as evidenced by the cement letters in the theater's facade. The theater closed in 1957 simultaneously with the nearby Grace. (Milwaukee Public Library.)

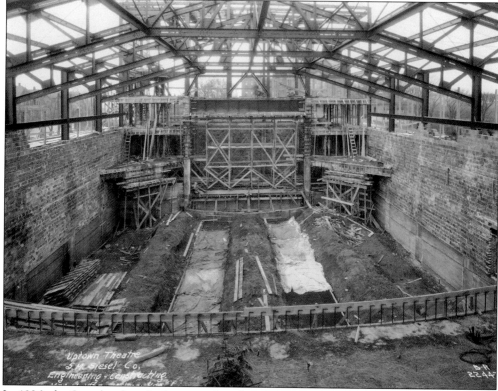

In 1926, the Saxe brothers broke ground at the intersection of Forty-ninth Street and North Avenue for construction of a 1,800-seat theater to serve residents who lived on the city's northwest side. By March 14, 1927, the theater's progress was apparent in this contractor's photograph. (Milwaukee Public Library.)

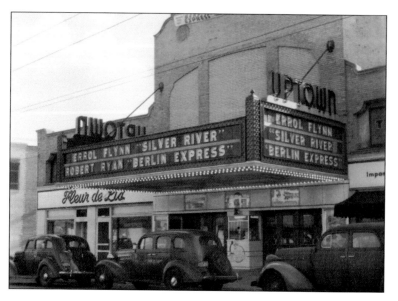

The Uptown was modeled after a Roman villa, with elegant interior murals and custom-made chandeliers. The theater closed in 1981 and remained vacant for 20 years until it was torn down for the Milwaukee Police Department's Third District station.

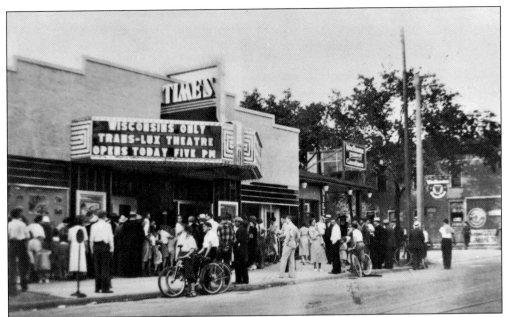

The Times had the distinction of being Milwaukee's only Trans-Lux theater, a rear-screen projection process. The 500-seat theater opened June 12, 1935. (Courtesy of Eric Levin.)

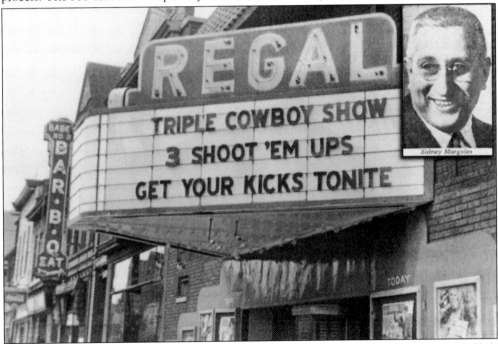

The Regal at Seventh and Walnut Streets opened as the Rose. The tiny theater presented Yiddish dramas for the Jewish population of the area. One of the theater's early performers was Paul Muni, who became one of Warner Brothers' biggest stars. In the 1940s, the neighborhood was known as "Bronzeville," because the population and businesses had become largely African American. The final operator of the theater, Sidney Margoles, played westerns and comedies mixed in with foreign and art films until 1958. (Courtesy of Sidney Margoles.)

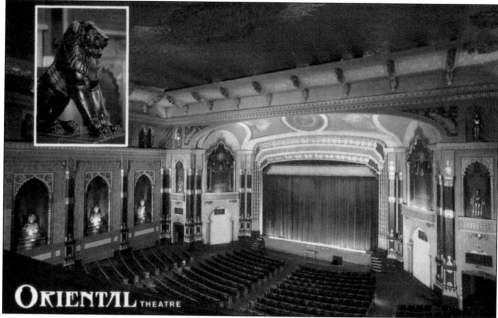

ORIENTAL THEATRE

The Oriental, built in 1927 at a cost of $1.5 million, was an elaborate mix of Indian, Islamic, and Byzantine architecture. Teakwood timbers, three 8-foot chandeliers, 2,000 yards of silk, and a tiled staircase to the balcony and promenade all added to the wonder of the theater. The opening-night program included the Arabian Nights Orchestra, newsreels, cartoons, an organ recital, and the film *Naughty but Nice*, starring Colleen Moore. The price of admission was 40¢, and the 2,300-seat house was filled to capacity for three consecutive shows.

The Shorewood opened in 1929. With 1,200 seats, the theater was larger than many neighborhood houses but only enjoyed modest success. It was closed by 1952.

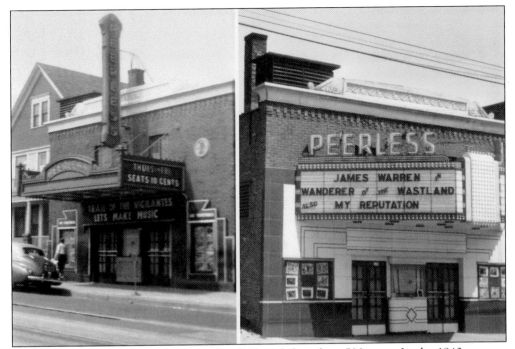

The Peerless on Center Street opened in 1913 with less than 500 seats. In the 1940s, owner William Heiman modernized the theater's appearance (right). The Peerless closed in 1958. (Courtesy of Karl Thiede.)

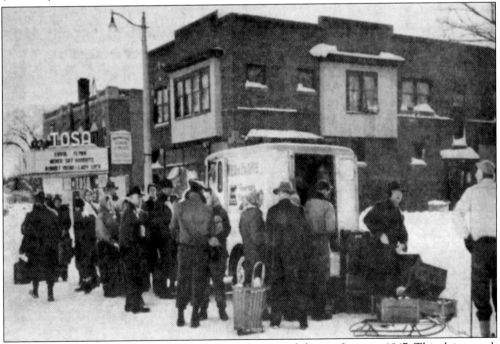

A huge snowstorm shut most of the city down for several days in January 1947. This dairy truck set up shop in front of the Tosa on North Avenue to serve homebound customers. (Courtesy of the *Milwaukee Journal Sentinel*.)

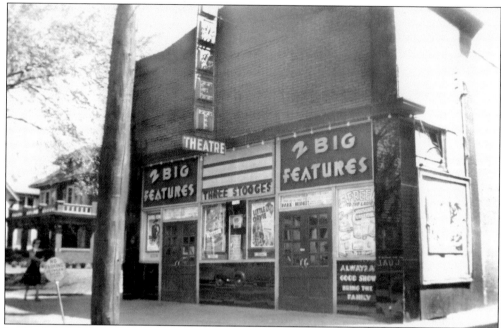

Located at Eighth and Mitchell Streets, the Central opened in 1910. Over the next 43 years, it was known by five additional names. The Midget was perhaps the most appropriate, as the tiny theater had only 240 seats. (Courtesy of Karl Thiede.)

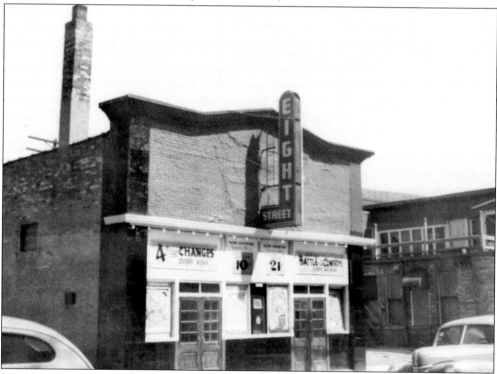

In addition to the Central and Midget, the Eighth Street theater was also known as the Pulaski, Pola Negri, Popularity, and the Delta before closing in 1953. (Courtesy of Karl Thiede.)

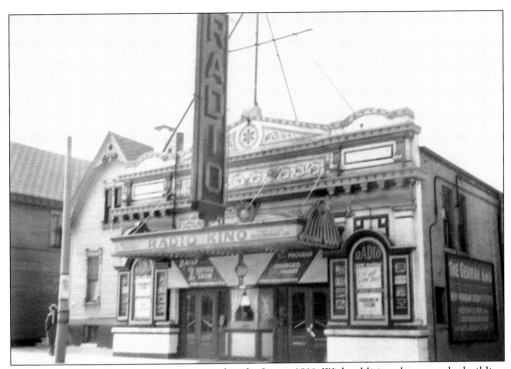

The Radio on Fond du Lac Avenue opened as the Iris in 1911. With additional names, the building tied with the Central on Mitchell Street for the Milwaukee theater address with the most names. (Courtesy of Karl Thiede.)

In addition to the Iris and Radio, the Kino was also called the Castle, Show, and American. The theater was still showing films in German when it closed as the Kino in 1966. (Courtesy of Karl Thiede.)

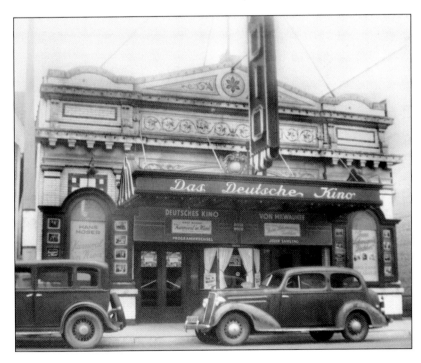

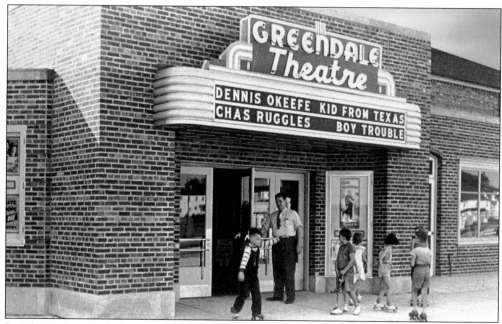

In 1939, Casimir Goderski opened the Greendale in a community planned by the federal government. Modeled after the quintessential American small town, Greendale's main street also had a civic center, fire station, and library. When the Southridge shopping center cinemas opened in 1968, the Greendale closed.

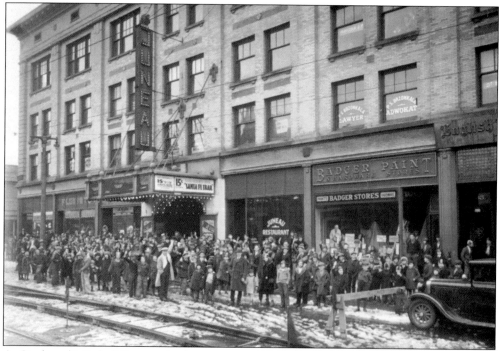

At Sixth and Mitchell Streets, the Juneau opened in 1910 as a vaudeville and dramatic theater. Two years later, the Saxe brothers turned the 1,100-seat house into a movie theater. Shown here in 1930, the Juneau operated until 1965.

Five

PIONEERS AND PERSONALITIES

Harold J. Fitzgerald began his career in 1911 as an usher at the Saxe-run Alhambra. He became district manager of the Saxe Theaters by 1924. When the Saxe chain was acquired by Fox-Wisconsin in 1927, Fitzgerald was named president of the company, overseeing 65 theaters across the state until his retirement in 1954. When the Varsity opened in 1937, Fox-Wisconsin moved its corporate offices from the sixth floor of the Carpenter Building. (Courtesy of Evelyn Conway.)

In 1902, sign painter Thomas Saxe and his brother John acquired a failing nickel theater at Second Street and Wisconsin Avenue. They renamed it the Theatorium. With 242 seats, it was the largest moving picture theater to date in Milwaukee. Over the next 25 years, the Saxe brothers operated nearly 60 houses across Wisconsin. (Courtesy of Mary Granberg.)

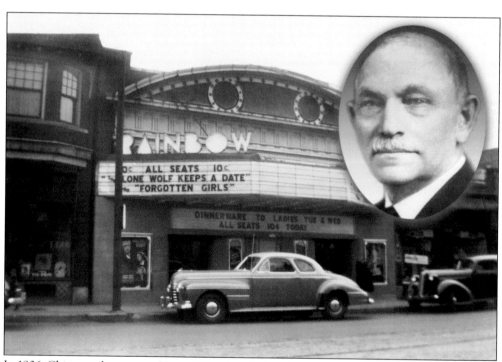

In 1906, Chicago saloon owner Henry Trinz thought his city to be overcrowded with seven theaters. He came to Milwaukee and opened the Empire on Mitchell Street with financial backing from the Schlitz Brewing. With the help of brothers Aaron and Samuel, Trinz acquired the Columbia before opening the Avenue, Savoy, and Rainbow Theaters. (Courtesy of Karl Thiede.)

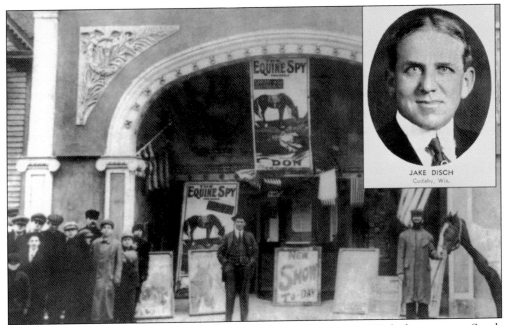

Jacob Disch managed Kenosha's Kimball Opera House in the early 1900s before opening South Milwaukee's Lyric in 1909. He then took over the Coliseum Theater in Cudahy. In 1912, investor Jacob Spies and Disch built the Majestic on Packard Avenue. One of the films they showed that year was *The Equine Spy*. In 1927, Disch and partner Lucas Unger built the New Majestic on Layton Avenue. Disch died in 1960 at age 86. (Courtesy of Astortheater.org.)

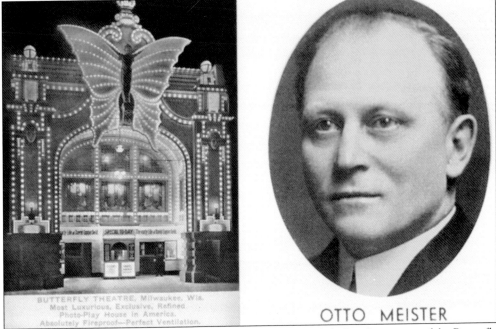

With its gold and red color scheme and thousands of colored lightbulbs, the interior of the Butterfly was exceptionally elegant movie. A 27-foot terra-cotta butterfly with 1,000 lights graced the facade, which was lit with an additional 2,000 bulbs. (Courtesy of Hugh Swofford.)

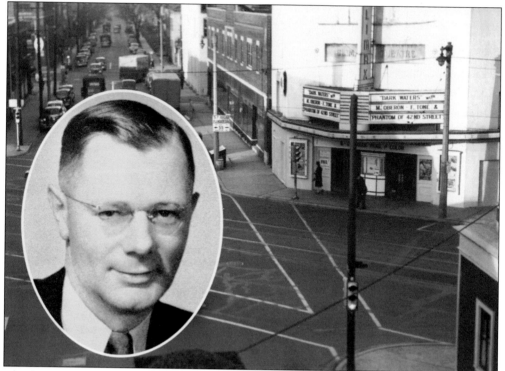

Charles Trampe started as a projectionist at the Owl before moving on to the Idle Hour, Queen, Comfort, and Toy Theaters. In 1923, he acquired the Rainbow and Climax Theaters and the Majestic in Cudahy. Trampe was a leader in the formation of the Wisconsin chapter of Variety Club, a showman's charitable organization. He also started Film Service Inc., a company that transported film, posters, and other supplies to theaters. (Courtesy of Milwaukee County Transportation and Public Works.)

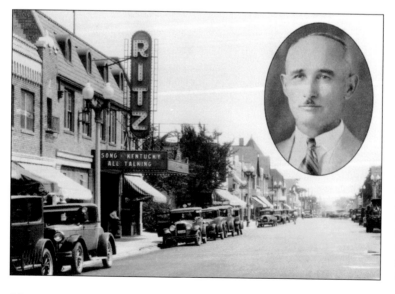

Michael Brumm opened the Princess Theater at Thirty-fifth Street and Villard Avenue in 1912. Ten years later, he closed the Princess and built the 840-seat Ritz across the street. After his death, Brumm's son Arnold managed the theater until the 1960s, which was when it became a Marcus Theater called the Villa.

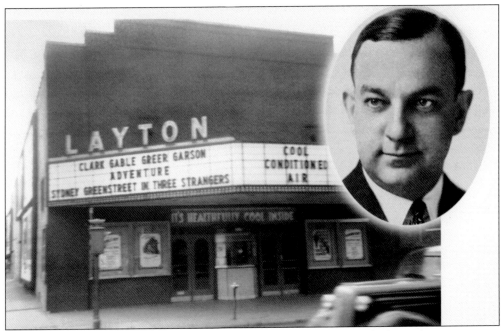

George Levine was a rising star in the Universal organization until he backed out of an engagement to owner Carl Laemmle's daughter Rosabelle. Levine resigned from Universal and ran the Grace and Pearl until 1957. He operated the Layton Park until 1972, which was when it was torn down to accommodate construction on South Twenty-seventh Street. Levine died February 1974 at the age of 82. (Courtesy of Wally Konrad.)

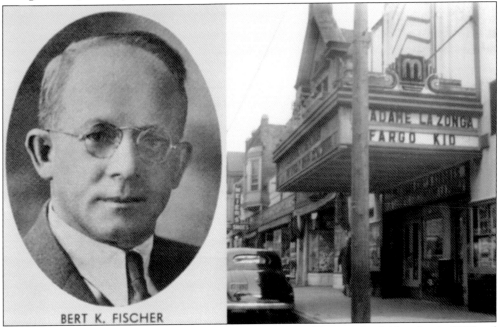

Burt K. Fischer opened Manitowoc's Crystal Theater in 1901. He moved to Milwaukee in 1908 and opened the Mozart and Alamo Theaters on Milwaukee's south side. Fisher was among the earliest advocates on behalf of independent theater men. He died in 1947. (Courtesy of Karl Thiede.)

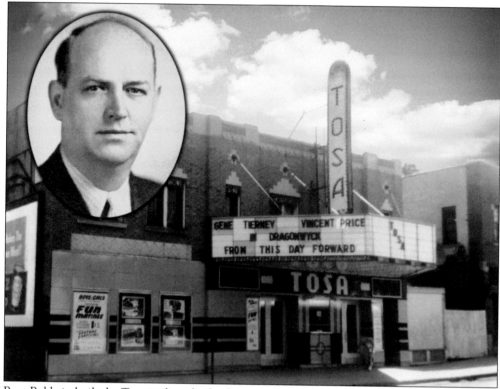

Ross Baldwin built the Tosa in the suburb of Wauwatosa in October 1931. His wife, Dorothy, sold tickets, and his children ushered and did the cleaning. Ben Marcus bought the theater in 1940. (Courtesy of Rosebud Entertainment.)

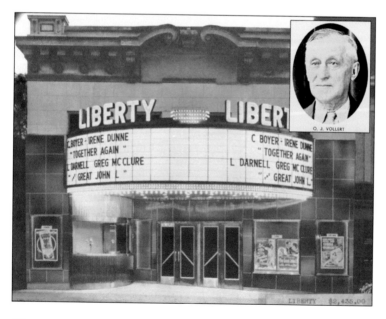

The Liberty was one of several theaters located within the once-thriving lower Vliet Street business district. Oscar Vollert operated the Liberty until it closed in 1966. (Courtesy of Poblocki Sign Company.)

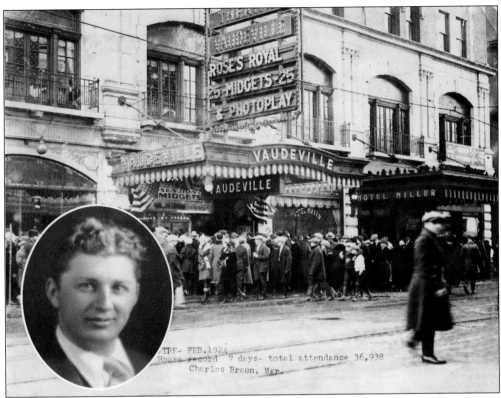

In 1905, 13-year-old Charles Braun sold candy at the Bijou Opera House. Two years later, he was the assistant treasurer at the Crystal. In 1916, the Saxe brothers made him manager of the Miller. Braun booked hundreds of singers, dancers, comedians, and other performers, but his favorite act was Ted Healy, who played the Miller in 1922 with a young Moses Howard (later Moe of the Three Stooges). In 1932, after stints at the Garfield and Modjeska, Braun began managing theaters in Hartford, Lake Delton, Viroqua, Richland Center, and a dozen other Wisconsin towns. He died in 1968. (Courtesy of Sue Braun.)

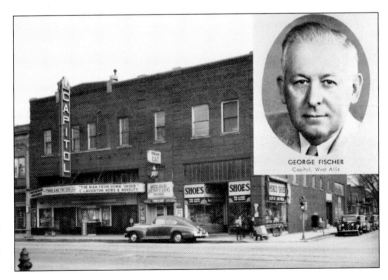

George Fischer retired from 50 years in show business in 1946. He started as a program boy at the Alhambra and was managing the theater before he turned 20. In the course of his career, he ran the Milwaukee on Teutonia, the Capitol in West Allis, and the National. (Wisconsin Historical Society #47846.)

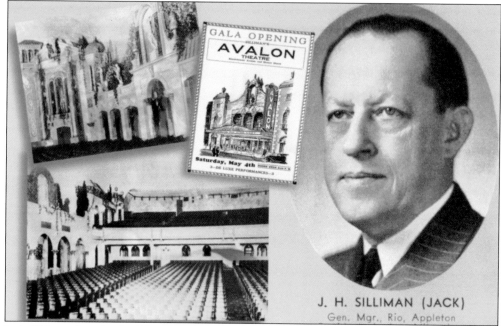

Jack Silliman bought the Liberty in 1912 and soon owned the Downer, Murray, Astor, Jackson, State, Riviera, Juneau, Kosciuszko, and Lake. In 1926, he sold his chain to Universal and opened the Venetian. In 1929, Silliman opened the Avalon, which had the distinction of being the first Milwaukee theater built for sound pictures. At the age of 57, he died in 1942. (Courtesy of Eric Levin.)

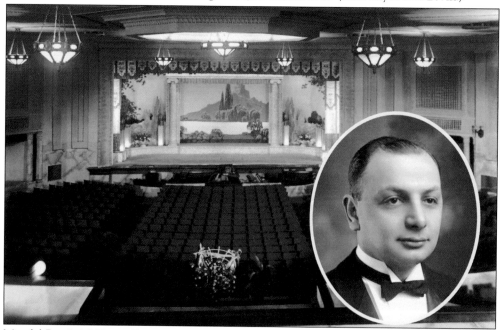

Mendel Rice's 1,200-seat Riviera at Tenth Street and Lincoln Avenue was more beautiful than most neighborhood theaters of its size. In 1922, the Riviera was purchased by Jack Silliman. It later became part of the local Universal, and then Warner, theater circuits. The Riviera closed in 1954. (Courtesy of University of Wisconsin-Milwaukee, Golda Meir Archives.)

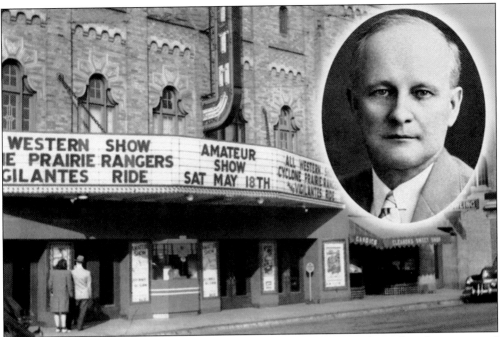

With excessive taxation and other legislative matters threatening the independent theater owners' existence, Zenith owner Edward Maertz helped organize a protective association to give them a voice in the state capitol.

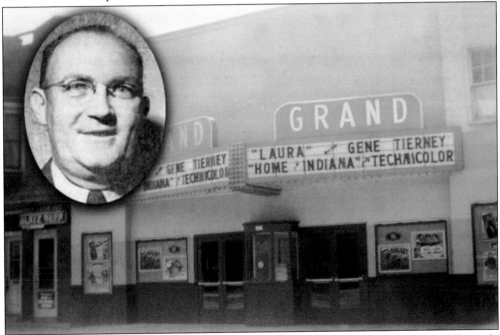

In 1927, Andrew Gutenberg turned the Grand into an "atmospheric" theater, a popular style of the day. Blue spotlights shown onto a dark blue vaulted ceiling gave patrons the illusions of sitting beneath a night sky. Milwaukee's other atmospheric theaters were the Venetian, Egyptian, National, Avalon, and Zenith. (Courtesy of Wally Konrad.)

Harold Shaffer landed a job at the Tower after providing his school report card and reference letters. He recalled that candidates who did not exhibit exemplary hygiene, manners, and speech were not selected for employment. In 1930, Shaffer climbed to the Tower's roof and posed for this shot in front of the Wells Street sign. (Courtesy of Harold Shaffer.)

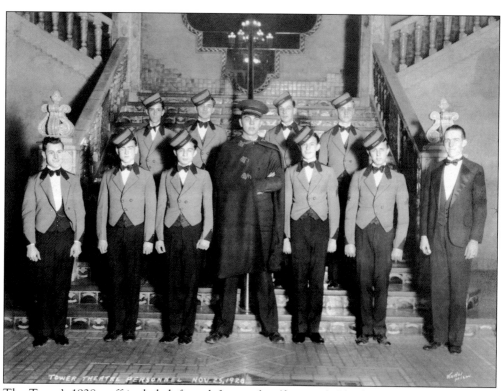

The Tower's 1928 staff included, from left to right, (first row) Charles Conway (chief usher), George Hartwell, Harry Pack, Fred Udick (door captain), Ray Ostreicher (sergeant), Robert Luck (corporal), and Luchin Hull (assistant manager); (second row) Harold Shaffer, Roy Kimple, Ed Steinkellner, and Allen Slotby. (Courtesy of Evelyn Conway.)

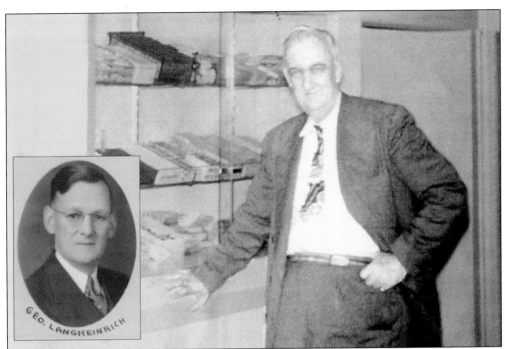

Musician Paul Langheinrich was a familiar figure on 19th-century stages like the Standard and the Academy of Music. The bandleader was also in demand to play at summer amusement spots like Ravenna Park in Shorewood. In 1914, Langheinrich built an 800-seat theater, the Burleigh, at Tenth and Burleigh Streets. After his death in 1936, sons George (inset) and Paul Jr. continued to operate the theater. (Courtesy of Claudia Ison.)

In the 1940s, the first concession stand at the Times was built against the wall without a customer counter. Because the theater was originally built as an automobile dealership in 1923, the space allotted for the lobby was disproportionately small for an auditorium with 500 seats. (Courtesy of Paul Finger.)

Prior to 1940, theater audiences typically purchased snacks and beverages from an independently owned sweetshop nearby. Concession stands like this one at the Oakland were first inspired with the premiere of *Gone with the Wind* in 1939. Coca-Cola, a sponsor of the film, insisted its beverage be made available to audiences for the entire duration of the film. Theater owners across the nation soon made snacks and soft drinks available in their lobbies. (Courtesy of Milwaukee County Historical Society.)

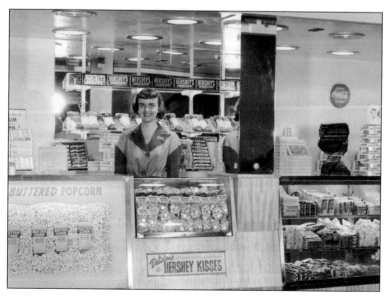

At first, theaters sold popcorn, bottled soft drinks, and a small variety of candies. The Venetian Theater's concession area was just one of many to be enlarged after World War II. (Courtesy of Fred Stanger.)

Zenith owner Edward Maertz's daughter Frances earned $5 a week as cashier, a position she held until 1929. Her younger sister Helen (pictured) took over until her marriage in 1936. Her father hired a Pathé News cameraman to film the ceremony, and Helen's wedding was proudly shown as part of the following week's newsreel presentation. A cousin, Elwood Strande (right), ushered and played the theater's Kilgen organ. (Courtesy of Frances Maertz.)

Theater managers were required to develop at least one major promotion per month. In January 1930, the Paradise staff dressed as racecar drivers and mechanics for the opening night of *Speedway*. Pictured are, from left to right, Ralph Rehbenk, Robert Berno, Robert Flint, Clarence Fischer, Charles Conway (chief usher), Clarence Guest, Cliff Hlaska (assistant manager), and Edward Erie. (Courtesy of Evelyn Conway.)

Universal CEO Carl Laemmle (left) visited Milwaukee's Universal Film Exchange in 1923. The exchange made it easy for managers to get films, posters, ad slicks, and other materials sent directly to their theaters. Most of the major studios maintained an exchange in town, and several were located on the site of the present Public Museum, near Seventh and Wells Streets. (Courtesy of Wally Konrad.)

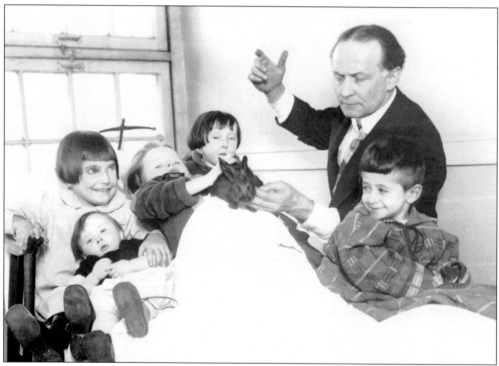

World-famous magician Harry Houdini is seen here entertaining young patients at the newly opened Milwaukee Children's Hospital in 1925. Houdini, born Erich Weiss in 1874, lived in Milwaukee for several years, beginning in 1882. After seeing a magic show at Litt's Dime Museum in 1886, Houdini knew he would be a magician. He returned to Milwaukee many times over the years and performed at the Wonderland Museum, escaped from the Milwaukee jail, and appeared at the Majestic and Orpheum Theaters. In 1916, Houdini extracted himself from a straitjacket while suspended 40 feet above the street. He died on Halloween in 1926.

In 1935, Polish immigrant Ben Marcus bought an old department store in Ripon, Wisconsin, and made it into a 500-seat theater, the Campus. He then bought theaters in Tomah, Sparta, Reedsburg, Oshkosh, Appleton, and Neenah. In 1940, Marcus acquired the Tosa and Times in Milwaukee. (Courtesy of Marcus Corporation.)

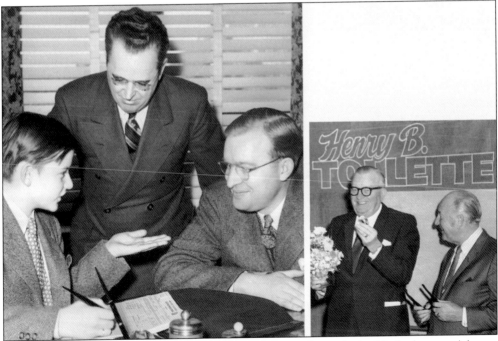

In 1922, Henry Tollette (at left, sitting to the right; at right, with the black glasses on) began his theater career at age 14 as a janitor at Madison's Fuller Opera House. In 1930, he joined Fox-Wisconsin. By 1943, he was a district manager of 30 Milwaukee theaters. When Roddy McDowall was in town to promote My Friend Flicka, Tollette and another Fox executive, Jack Lorentz (at left, standing), played host to the young star. In 1944, independent theater owner Ben Marcus convinced Henry Tollette to leave Fox and join his executive team as head film buyer. (Courtesy of Marcus Corporation.)

Don Goeldner visits with his grandfather at the Paradise in 1956. Carl Goeldner began as a projectionist in 1914 at the Princess. Starting in 1969 at George Levine's Layton Park, Don followed his father and grandfather's footsteps. "I always knew I'd be a projectionist," Goeldner said. "At our house, Christmas, Thanksgiving, and Easter were celebrated a day early, because my father and grandfather had to work holidays." (Courtesy of Don Goeldner.)

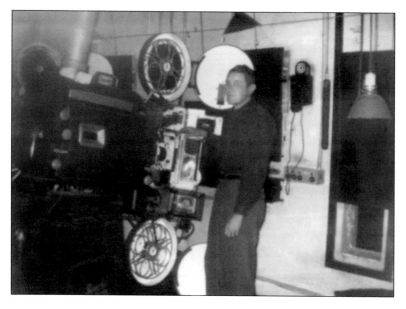

Pictured is Russell Goeldner in the projection booth at the Garfield around 1945. Goeldner's father and his son were also projectionists. The family's three generations in Milwaukee theaters spanned 71 years. (Courtesy of Don Goeldner.)

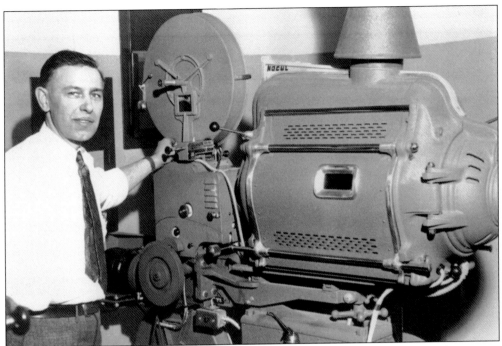

Aragon owner Casimir Goderski opened the Airway at Howell Avenue and Norwich Street in 1949. One son, Jerome, managed the theater, while the other, Eugene (pictured), handled the film and projection duties. (Courtesy of Connie Murphy.)

Opening night at the Airway was attended by, from left to right, Ben Poblocki, who installed the exterior neon signs; Myles Belongia, the theater's architect; and owner Casimir Goderski. The Airway closed in 1966. (Courtesy of Connie Murphy.)

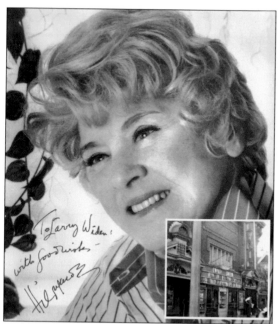

Hildegarde Sell grew up at Fifty-fourth and Vliet Streets in Milwaukee. She became a pianist at the Lyric Theater (inset) while a music student at Marquette University. In 1926, she went backstage at the Wisconsin Theater and was hired by a traveling vaudeville show. Over the years, Hildegarde evolved into the elegant chanteuse that Eleanor Roosevelt called, "The First Lady of supper clubs." One of the most popular cabaret acts in the world, the Gershwins wrote *My Cousin from Milwaukee* just for her. Hildegarde performed on a regular basis until 1998 and died seven years later at the age of 99. (Courtesy of Hildegarde Sell.)

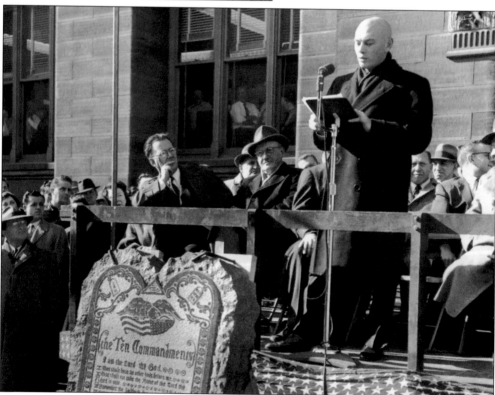

To promote *The Ten Commandments*, director Cecil B. DeMille donated a granite monument to Milwaukee City Hall; Actor Yul Brynner led the dedication. In 2002, faced with a freedom from religion lawsuit, the City of Milwaukee placed the stone in a park near St. Joseph's Hospital. (Courtesy of Joe Reynolds.)

Actor Jeffrey Hunter graduated from Whitefish Bay High School in 1944. His career began with a small role in *Julius Caesar* with Charlton Heston. Later known for *The Searchers* and *King of Kings*, Hunter returned to Milwaukee in 1952 to spend Christmas with his parents. While in town, he visited the newly opened Fox Bay Theater on Silver Spring Drive.

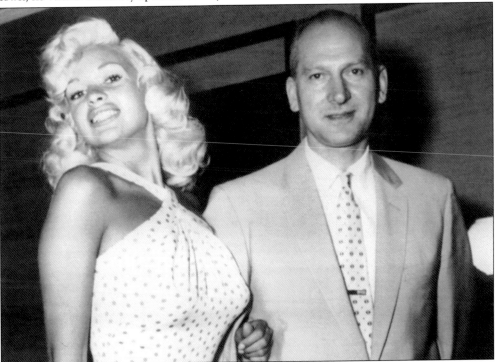

Veteran theater manager Joe Reynolds was often in charge of escorting visiting actors and actresses around town. His easy-going manner made him the ideal person to take stars like Jane Mansfield to press interviews and other scheduled personal appearances. (Courtesy of Joe Reynolds.)

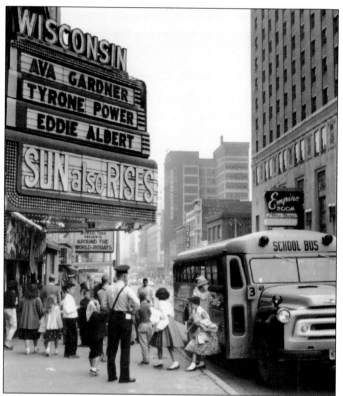

Although the marquee at the Wisconsin reads, *"The Sun Also Rises,"* this busload of children was on a field trip to see Walt Disney's nature film *Perri*. (Courtesy of Milwaukee County Historical Society.)

"Popcorn and a movie" has become one of those rituals handed down from generation to generation. This family is enjoying an outing at the Garfield in the late 1950s. (Courtesy of Milwaukee County Historical Society.)

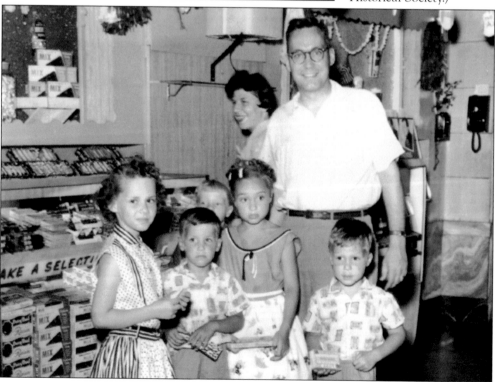

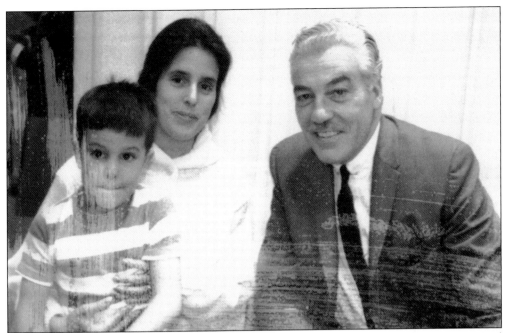

The author and his mom, Marlene Widen, met Cesar Romero in 1961. In town for a personal appearance at a menswear store, Romero was still a few years away from his iconic appearance as the Joker on television's *Batman*. (Courtesy of Marlene Widen.)

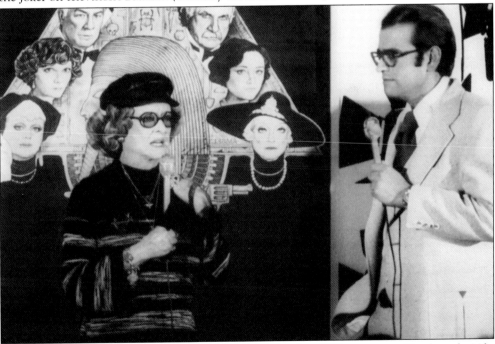

Bette Davis appeared at Mayfair shopping center in October 1978 to promote *Death on the Nile*. The legendary actress delighted the crowd when she exhaled a huge plume of cigarette smoke and delivered the famous line, "What a dump!" Davis was accompanied by Bruce Bennett (at right), a former film critic with WISN-TV.

Len Widen is seen here with *Great Gatsby* star Mia Farrow during her visit to Milwaukee in 2000. (Courtesy of Len Widen.)

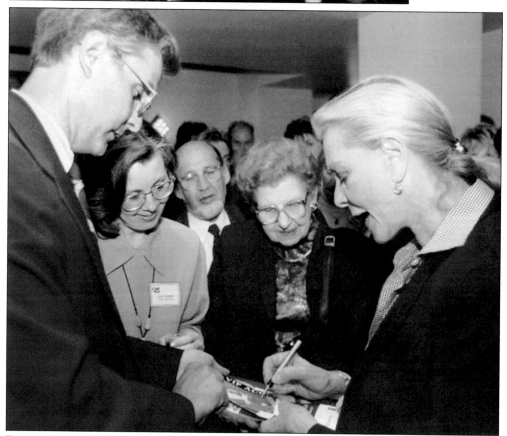

From left to right, Larry and Judi Widen and Lillian Crupi meet legendary actress Lauren Bacall backstage at the Marcus Center for the Performing Arts in 1998. (Courtesy of *Milwaukee Journal Sentinel*.)

Six

AFTER WORLD WAR II

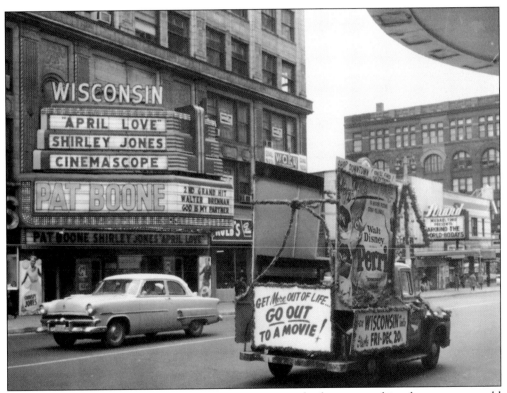

By 1959, the once-powerful Fox-Wisconsin circuit was broken up, and its theaters were sold to various independent operators. Former Fox employees Nick and Al Frank purchased the Wisconsin, Palace, and Strand. The Garfield, Modjeska, Oriental, Tower, and Uptown went to local businessman Lando Gran, who was also a founder of the WISN television station. The New York–based Prudential Theaters bought both the Gran Houses and the Frank brothers' houses in 1963. Nick Frank recalled that the Prudential deal was especially profitable for the Saxe heirs. "They were still the landlords on a lot of those theaters," he said. (Courtesy of Milwaukee County Historical Society.)

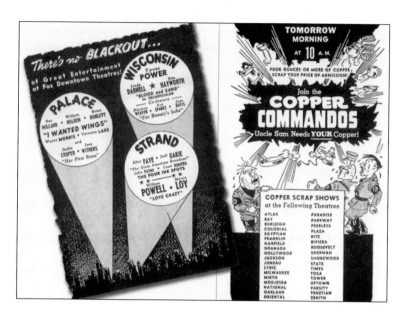

When World War II ended, it was evident that movie theaters had been one of the staunchest of all community supporters. Bond drives, newsreels, and other in-theater efforts began in 1942. Hollywood also tapped into America's patriotism, releasing films with soldiers, G-men, and private detectives fighting the war in a variety of ways.

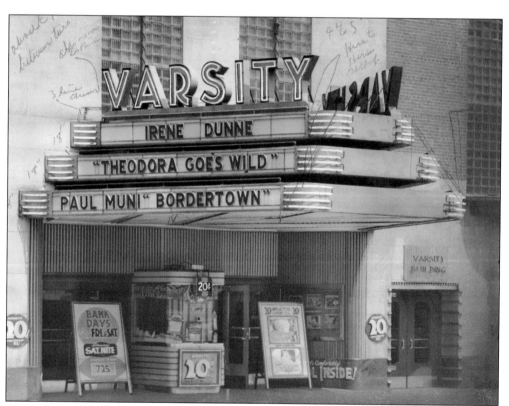

When the Varsity closed in April 1976, a 39-year tradition of entertaining Marquette University students came to an end. On the last night of operation, the Varsity was showing *Blazing Saddles*. (Courtesy of Evelyn Conway.)

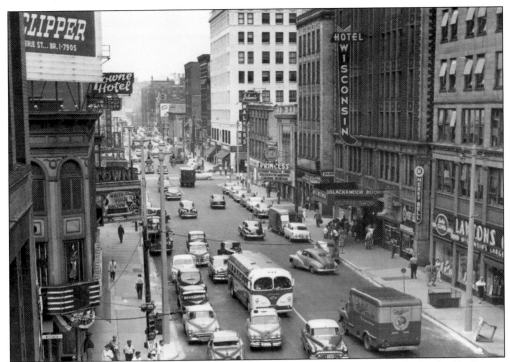

When the first-run Towne was playing *White Witch Doctor* for $1, the Princess had a double feature for 60¢. Manager Wally Konrad kept the Princess profitable by changing movies nine times a week. "We had three weekday changes, plus a Saturday special, and a triple feature on Sundays," he said. "We ran from 9:00 a.m. until midnight every day." (Milwaukee Public Library.)

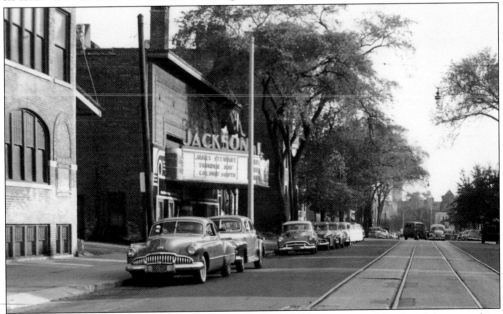

By 1953, weekly theater attendance was on the decline. A change in neighborhood demographics and the availability of television in the home were two reasons theaters like the Jackson were forced to close their doors. (Milwaukee Public Library.)

NOTICE!

While the curfew is in effect the following
PRUDENTIAL THEATRES
will hold DAILY MATINEES

PARADISE
UPTOWN
MODJESKA
ORIENTAL
TOWER
RUBY ISLE
MAYFAIR

} One
Show Only
Starting
at
1:30

CINEMA 1
SOUTHGATE

} One show
at 2 p.m.

CINEMA 2, continuous from 12 noon
PRINCESS, continuous from 9:30 a.m.
LAYTON, 2 shows starting at 12:30

For additional information please call the individual theatre.

Racial tensions in Milwaukee reached their breaking point in July 1967. When violence erupted in several urban areas, Mayor Henry Maier placed the city under a 24-hour curfew. Many businesses, including theaters, closed for 10 days.

The 1967 racial violence and resulting curfew transformed Wisconsin Avenue from the state's busiest commercial district into an eerie urban ghost town.

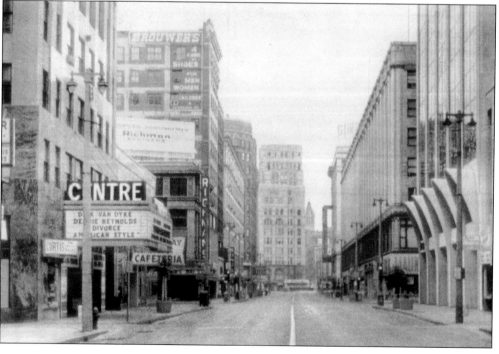

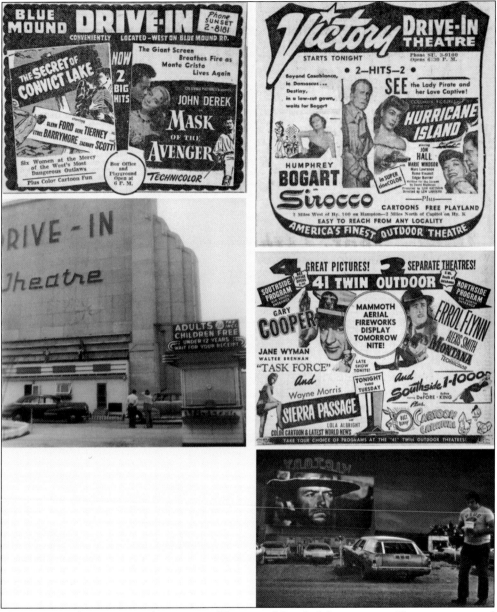

The first area drive-in opened in 1940 on Bluemound Road. Admission was 35¢ per person, and the lot held 450 cars. The *Journal* called it "the acme of informality," noting that casually dressed people smoked, talked, and crunched loudly on snacks. One couple had their car radio on during the newsreel so they could "listen to Bob Hope and watch President Roosevelt." Ushers directed traffic, while vendors went from car to car selling food and soft drinks. The heyday of drive-ins was short, and many were gone by 1985. (Courtesy of Astortheater.org.)

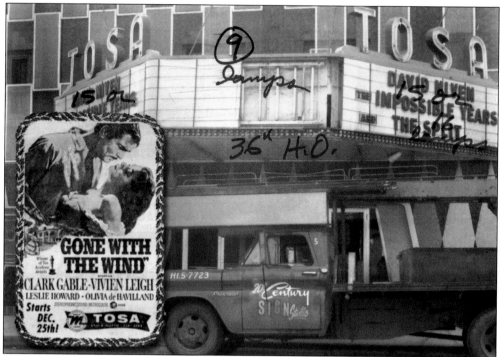

The Tosa's 1940s-era marquee was sorely in need of repair by 1969. Periodic updates to the facade continued until 1999, which was when the theater was completely remodeled and renamed the Rosebud Cinema Drafthouse. The Tosa showed *Gone with the Wind* (inset) on Christmas Day 1968. (Courtesy of Rosebud Entertainment.)

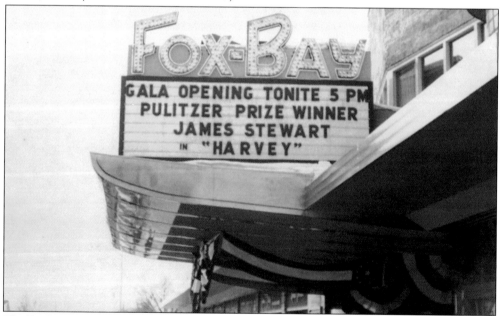

The Fox-Bay opened in 1950 at a point when some area theaters were falling on hard times. Located on Silver Spring Drive in the affluent suburb of Whitefish Bay, the Fox-Bay thrived on the patronage of young, postwar families who had moved from the city. (Courtesy of Gerry Franzen.)

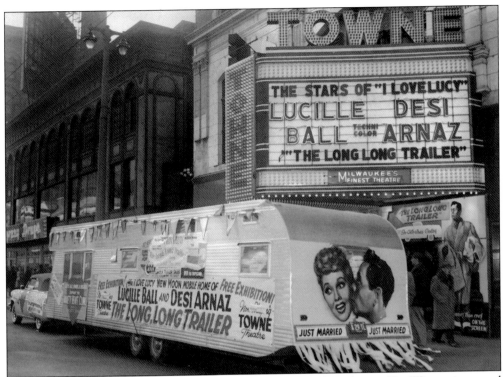

After operating the Miller as a second-run theater for a number of years, Fox-Wisconsin ceased its operation in April 1946. Independent exhibitors Andrew Spheeris and Spiro Papas, along with United Artists, invested $100,000 to renovate the theater and reopened it in December as the Towne. (Courtesy of Joe Reynolds.)

In 1947, the Telenews Theater on Wisconsin Avenue began showing a daily program of news from around the world. In 1957, the theater switched to an all-movie policy. In 1965, the theater was purchased by Ben Marcus and renamed the Esquire. When it closed in September 1981, everything in the theater was sold in a huge rummage sale. (Courtesy of Astortheater.org.)

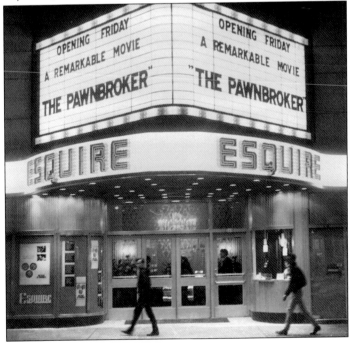

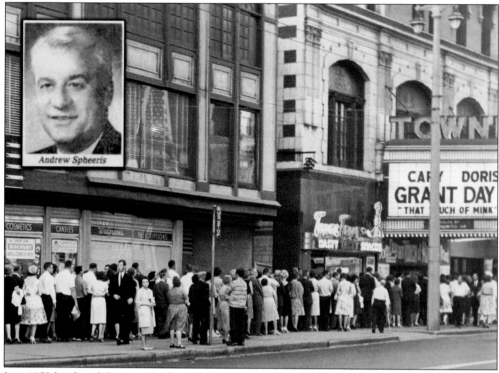

In a 1952 landmark lawsuit, Andrew Spheeris, operator of the Towne Theater, successfully sued the major motion picture studios for the right to bid on all films shown in Milwaukee. (Courtesy of Joe Reynolds.)

In 1948, the motion picture business was altered by an antitrust ruling that forbade movie studios from owning theaters. As Paramount, Warner, and the other studios sold their theaters, the new owners did not always have the means to keep them up. As a result, the once-grand temples of amusement began to disintegrate and then close. (Courtesy of Joe Reynolds.)

Huge crowds were not uncommon on Friday and Saturday evenings or weekend afternoons. Even though attendance didn't compare to the prewar years, veteran showman Joe Reynolds said, "Business was still pretty good downtown until the first-run pictures started going out to the mall theaters." (Milwaukee Public Library.)

To compensate for dwindling attendance, theaters like the Riverside offered closed-circuit telecasts of special events like the Indianapolis 500. On this night, however, *Planet of the Apes* was pulling a good crowd. (Milwaukee Public Library.)

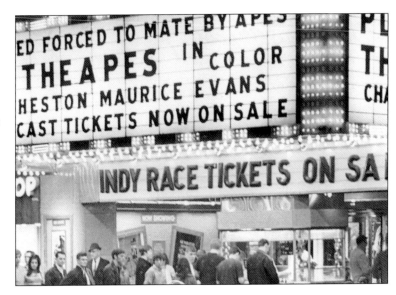

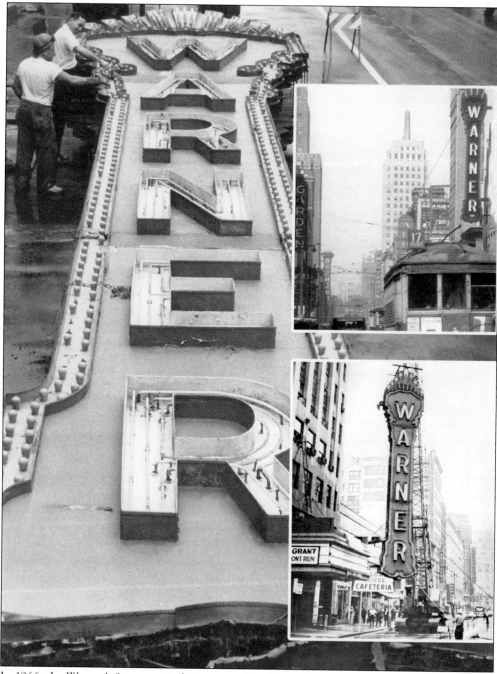

In 1966, the Warner's 8-ton vertical sign was taken down after 35 years. The first of these signs to come down was the Wisconsin's in 1937 and the last was the Riverside's in 1967. (Courtesy of *Milwaukee Journal Sentinel*.)

Seven

GHOSTS OF
THEATERS PAST

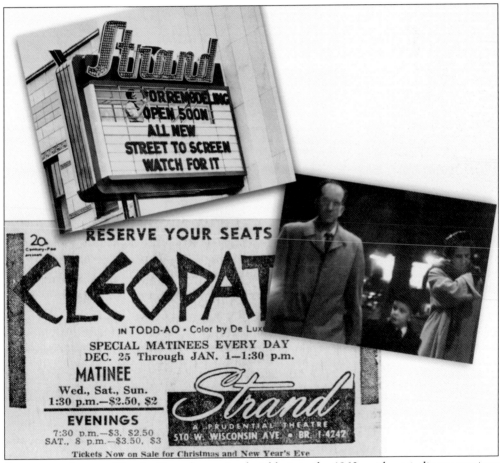

Downtown theaters, like the Strand, remained viable into the 1960s with periodic renovations and exclusive engagements of Hollywood's biggest pictures. The author accompanied grandparents Joe and Lillian Crupi (inset) to many movies as a child. (Courtesy of Lillian Crupi.)

Pictured are Frances (left) and Helen Maertz in front of the family-owned Comfort Theater on Hopkins Street in 1915. The girls would later work at their father's Zenith in the late 1920s. (Courtesy of Frances Maertz.)

Frederick Maertz opened the Comfort Theater in 1914. At the height of the Great Depression, his son Edward, who owned the nearby Zenith, renovated the ailing Comfort into a nightclub called Club Aztec.

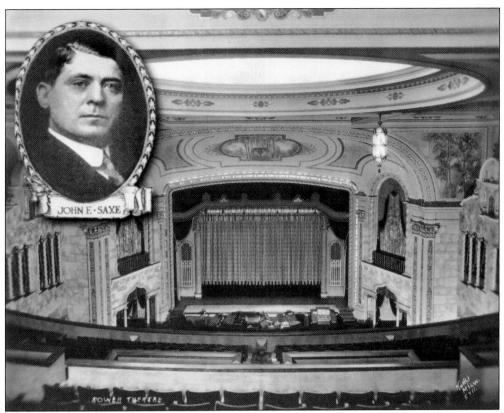

The ornate interior of the Tower at Twenty-seventh and Wells Streets was breathtaking when it opened in 1926. John Saxe (inset) was instrumental in securing the millions of dollars he and his brother Thomas needed to open lavish theaters like this one. (Courtesy of Albert Kuhli.)

City of Milwaukee employee Roosevelt Cooper is standing in what was once the Tower Theater's balcony.

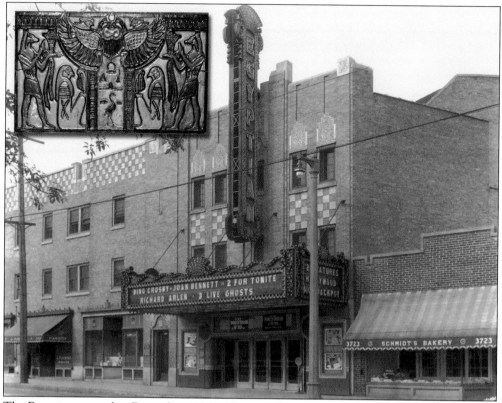

The Egyptian opened in December 1926 with a motif inspired by the recent excavation of King Tutankhamen's tomb. Egyptian Theaters sprang up in many major cities, and Milwaukee's version was designed by local architects Peacock and Frank to resemble a pharaoh's open-air courtyard.

Closed in 1967, the Egyptian stood vacant for almost 20 years before being demolished. (Courtesy of John A. Gross.)

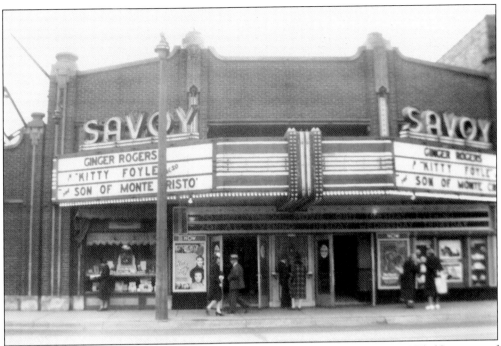

The Savoy on Center Street was also known as the Oasis until closing in 1975. (Courtesy of Karl Thiede.)

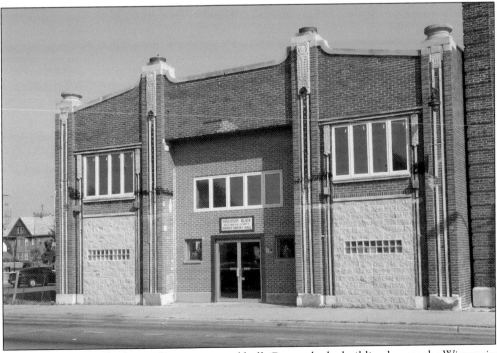

From 1975 to 1990, the former Oasis was a pool hall. Currently the building houses the Wisconsin Black Historical Society and Museum.

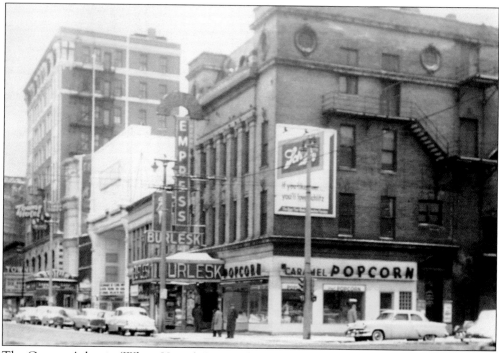

The Gayety, Atlantic (White House), Lotus Chinese restaurant, and the Towne Theater and hotel are all gone. The Towne was playing *Six Bridges to Cross* when this photograph was taken. To the right of the Lotus is the Goldfish uniform store. Originally the building was the Lawrence 3¢ restaurant in 1906, which became Otto Meister's Vaudette in 1908, the Magnet in 1923, and finally Meister's penny arcade in 1932. (Milwaukee Public Library.)

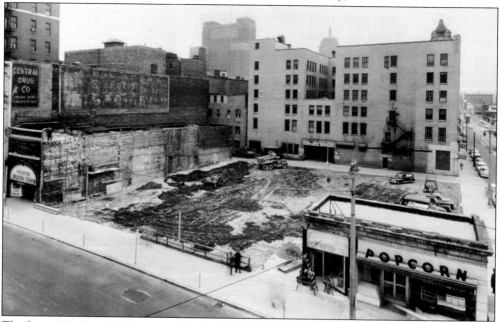

The former Vaudette (left) survived the first round of demolition in 1955, as did the Caramel Crisp popcorn shop, which was attached to the Gayety burlesque house. (Courtesy of Hugh Swofford.)

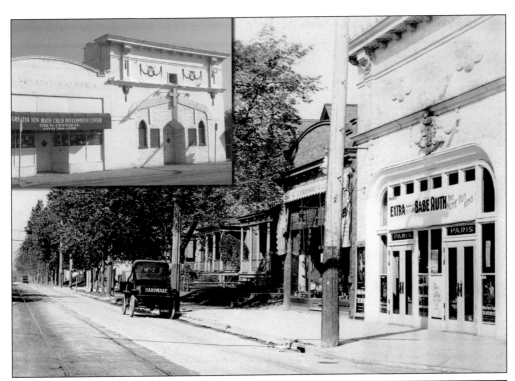

The pictures playing at the Paris in 1920 were *Babe Ruth: Home Run King* and *The Inferior Sex*. Owned by Frank Sears, the theater flourished until the advent of talking pictures. Comfort Theater owner Fred Maertz was an employee here in 1911. The former Paris (inset) is now a child-care center. (Milwaukee Public Library.)

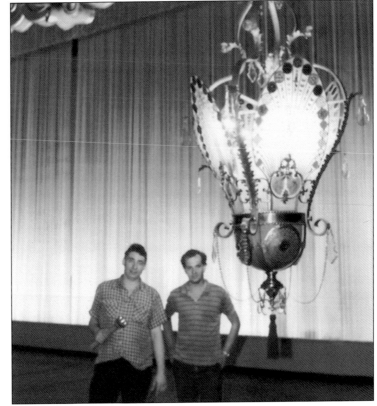

Historians Jim Rankin (left) and Scott Schultz lowered one of the original Warner chandeliers in 1985 for inspection and cleaning. (Courtesy of Scott Schultz.)

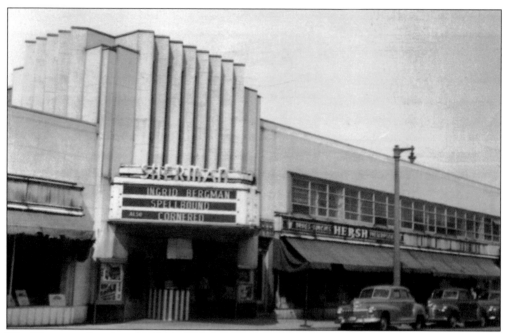

The Sherman closed in the 1970s. Various efforts to restore the theater in the last few decades, including one by Sen. Herb Kohl and Major League Baseball commissioner Bud Selig, have failed. Kohl and Selig recalled the Sherman as the place where they "figured out how to win World War II on many a Saturday afternoon." (Courtesy of Karl Thiede.)

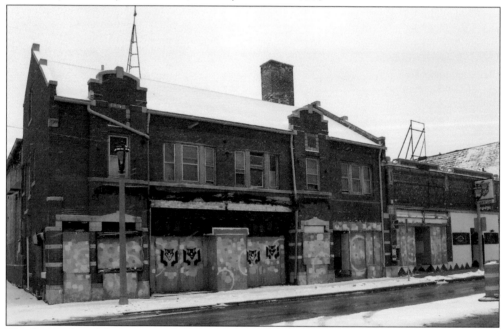

The former State Theater came back to life as a 1970s rock nightclub, which was known as the Electric Ballroom and later The Palms. The Ramones, Elvis Costello, Joan Jett, Rick Derringer, and Cheap Trick were among the many bands that played there. In 1981, a photographer snapped the famous picture of Plasmatics' singer Wendy O. Williams being arrested in the alley.

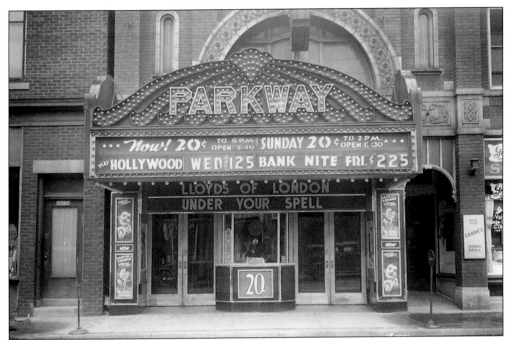

In 1985, a *Milwaukee Journal* editorial cited the Parkway as a magnet for crime. Because the theater showed X-rated films, the suburban men who patronized the theater were viewed as "easy marks" by thieves who operated in the area. (Milwaukee Public Library.)

The entire terra-cotta facade from the Parkway is now stored in Greg Filardo's basement. The writer and historian salvaged it piece by piece as the building was being demolished in 1990. (Courtesy of Stuart McCaskill.)

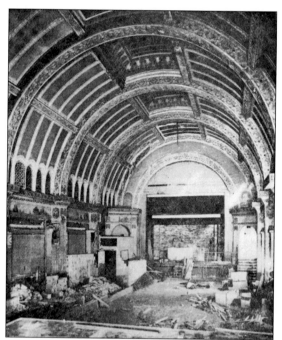

In 1919, the enactment of Prohibition dealt a deathblow to restaurants and other establishments operated by breweries. The 1890s-era Schlitz Palm Garden, located at Third Street and Wisconsin Avenue, was converted into the Garden Movie Theater, which operated from 1921 to 1955. Demolition on the once-grand building began on October 1, 1964.

Designer and architectural historian H. Russell Zimmermann has spent a lifetime rescuing fragments of Milwaukee buildings. As the Garden Theater was being demolished in 1964, Zimmermann found a piece of the original Palm Garden plaster that was untouched when the building was converted into a theater.

On Thursday, January 14, 1960, the Princess completed a run of *The Five Pennies*, starring Danny Kaye and Louis Armstrong. The next day, newspaper advertisements for the Princess read, "Frank and Daring" and "For Adults Only," setting the theater's course for its final 25 years. (Milwaukee County Historical Society.)

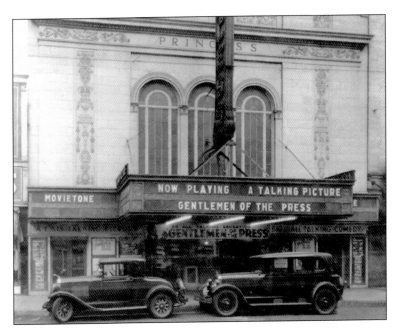

The Princess operated for nine decades before being demolished in 1984. In the foreground, from left to right, Judy Anderson, John Cisler, and Larry Widen have salvaged a few pieces of terra-cotta ornamentation from the wreckage.

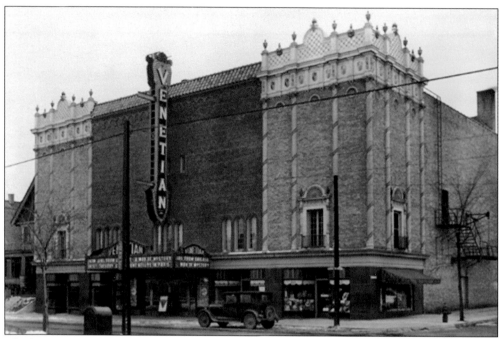

The 1,500-seat Venetian, located at Thirty-seventh and Center Streets, recalled the courtyard of an Italian palazzo with flowers, trees, and shrubbery. Plush blue-and-wine-colored draperies hung on walls inlaid with gold leaf.

Upon closing in 1954, the Venetian was used as a furniture store, record store, and a liquor store. After standing vacant for years, the building was torn down in April 2007. (Courtesy of Emily Widen.)

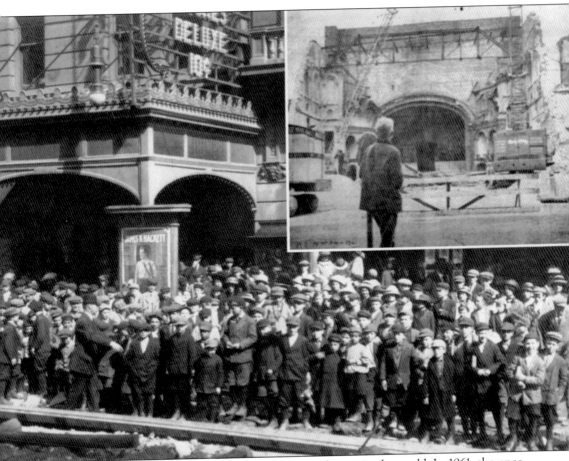

In 1912, the 3000-seat Alhambra was the largest movie theater in the world. In 1961, the once great theater fell to the wrecking ball (inset). (Wisconsin Historical Society #55830.)

DISCOVER THOUSANDS OF LOCAL HISTORY BOOKS FEATURING MILLIONS OF VINTAGE IMAGES

Arcadia Publishing, the leading local history publisher in the United States, is committed to making history accessible and meaningful through publishing books that celebrate and preserve the heritage of America's people and places.

Find more books like this at
www.arcadiapublishing.com

Search for your hometown history, your old stomping grounds, and even your favorite sports team.